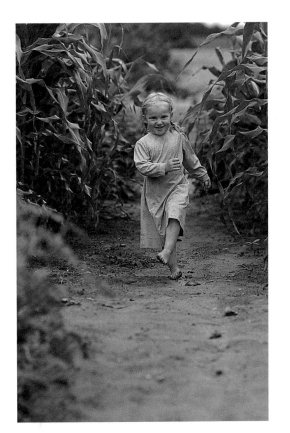

# Us Little People

## Mennonite Children

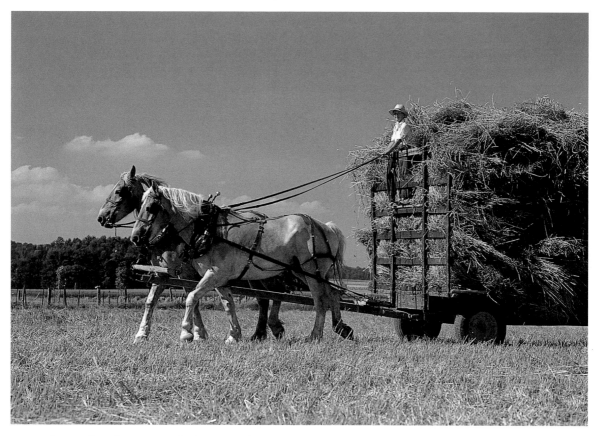

*It was a hot afternoon in early August and four Mennonite boys had just finished giving me a tour of their barn.*

*As we looked out over the yellowing grainfields, eight-year-old Solomon Martin turned to me and said, "Next week we are going*

*to bring in the grain and us little people will drive the teams." I realized then that he had given me the title for this book.*

*Thank you, Solomon.*

## Carl Hiebert

## My thanks to . . .

The children who openly allowed me to look into their world through my viewfinder.
The students who took the time to write and who graciously allowed me to read
their personal composition books and choose the stories I wanted. They are your gifts.
The teachers at Linwood and the parochial Mennonite schools who
generously accommodated my requests and encouraged their students to write.
Community residents, Mennonites and non-Mennonites alike,
who allowed me to tap into their experiences with these children.
Numerous friends who encouraged me to continue with this project.
A special thanks to Lee for the number of times you said, "Carl, this is *your* book. Do it."
Friends who offered insightful editorial feedback, especially Kim, Margaret, Penny, and Gerry.
My dear Mennonite friends Mathias and Nancy and extended family. Your friendship is a sacred trust.

Published by
BOSTON MILLS PRESS
132 Main Street
Erin, Ontario, N0B 1T0
Tel. (519) 833-2407
Fax (519) 833-2195
books@bostonmillspress.com
www.bostonmillspress.com

IN CANADA:
Distributed by Firefly Books Ltd.
3680 Victoria Park Avenue
Toronto, Ontario M2H 3K1

IN THE UNITED STATES:
Distributed by Firefly Books (U.S.) Inc.
P.O. Box 1338, Ellicott Station
Buffalo, New York 14205

Second printing, January 2003

**Cataloging in Publication Data**

Hiebert, Carl E., 1947-
Us little people: Mennonite children

ISBN 1-55046-395-0

1. Mennonite children — Pictorial works.  2. Mennonites — Social life and customs.
3. Children's writings, Canadian (English).* I. Title.

BX8128.C48H53 1998      779.92897'083      98–930336–5

**Publisher Cataloging-in-Publication Data (U.S.) is available.**

Design by Gillian Stead
Printed in Canada

*Dedicated to the Mennonite children of Waterloo County,*

*with whom I have spent countless hours over the past few years.*

*Some of you are already entering adulthood.*

*Your joy and love of life have touched me deeply.*

*Thanks for helping me with my own journey.*

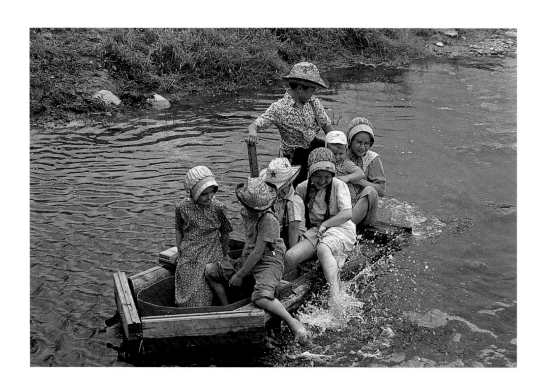

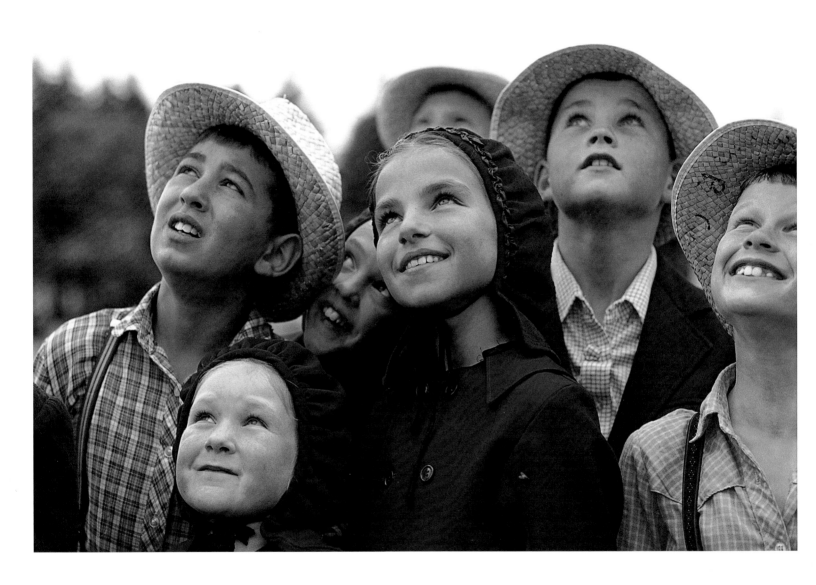

I first moved to Kitchener–Waterloo in 1972, mostly in search of work, but also intrigued by Waterloo County's Old Order Mennonites. My own roots are Russian Mennonite, a more progressive sect, and my city life contrasted dramatically with the horse-and-buggy transportation and communal barn-raisings that characterized these conservative Mennonites. Our only commonality seemed to be our origins in Europe over 400 years ago. How could we be so different yet both still call ourselves Mennonites?

Two years later I took a sociology course on the Mennonites of Waterloo County and began spending my winter Saturdays with my camera, driving back roads and meeting Mennonite farmers. But when spring came, my weekends once again became too crammed with sports — motorcycling, skiing, scuba-diving, sky-diving — for such passive activity.

In 1981 a hang-gliding accident left me paralyzed from the waist down and in a wheelchair. I continued to fly (now with an ultralight) and to photograph, producing the book *Gift of Wings* in 1995, but I also started to reflect seriously on my fundamental values. My thoughts drifted back to my Mennonite friends. With my wheelchair in the back seat of my car, I headed deeper into Waterloo County, this

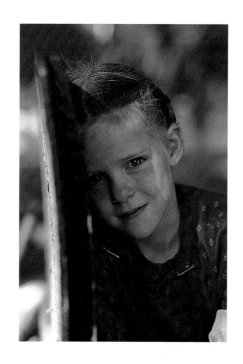

time with a more experienced photographic eye. I had no project in mind, simply a desire to satisfy my curiosity about my fellow Mennonites and to learn from them.

Unexpectedly, the photography became my first challenge. How could I obtain intimate photographs of a people who clearly eschew both cameras and photographs? The Old Testament commands, "Thou shalt not make unto thee any graven image." Photographs invite the honoring of a person instead of God.

The pictures that resulted in this book are a gift from my new-found friends, given slowly over the years as I acquired their trust. I tried to weigh each encounter carefully to decide if it was appropriate to photograph. Some days I never took the cameras out of the bag; other days I came home with a dozen rolls of film. Sometimes I thought I would explode from inner conflict — witnessing scenes so rich they begged to be photographed but realizing it would be inappropriate even to ask. Once I was invited into a kitchen to experience a quilting. Ten women, lost in delightful Pennsylvania-Dutch chatter, wove their stitches rhythmically into a Log Cabin quilt. The warm, diffused light of late-afternoon winter sun bathed the room. My cameras sat in the car, frustratingly close, but I knew that even my asking would disrupt this tranquility. I could only cherish the moment and lock it away in my memory.

At times I sat in my car and watched from the roadside. On other occasions, I spent hours just being with people, hanging out in woodworking shops or traveling back to the sugar bush with horse and sleigh. The moments when it felt right to photograph were

exceptional. When I finally asked parents if I could spend time with and photograph their children, they typically responded, "Well, sure, I guess that will be okay." When they asked why I was taking pictures, I explained that it was my hobby. A couple of years later, I found myself saying that maybe someday I would do a book.

Mennonites sometimes acknowledge their mixed feelings about photographs. Curiosity overcomes taboo and occasionally they ask for copies of photographs I have just taken. Children in particular can hardly wait to see themselves in pictures. When I showed my photos to a respected man of the community, he paused, turned, and with a just a hint of a smile said, "I'm not sure if I should even be looking at these pictures. But I sure like them."

What began as a vaguely defined project of documenting the Mennonite lifestyle gradually became something more specific. The serendipitous path I followed was lined with young faces — Salome, Lovina, Cleason, Amos — fresh faces, individual faces, always a delight. Though these smiles appeared only momentarily in my lens, they truly came into focus when they touched my soul.

What was it about these children that drew me so compellingly? I had photographed youngsters before, but this was different. I felt an obvious fascination with their lives, but also a certain yearning and melancholy. Were these children somehow reviving memories of my own childhood?

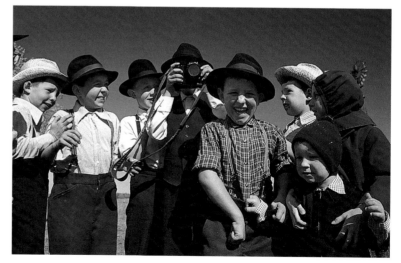

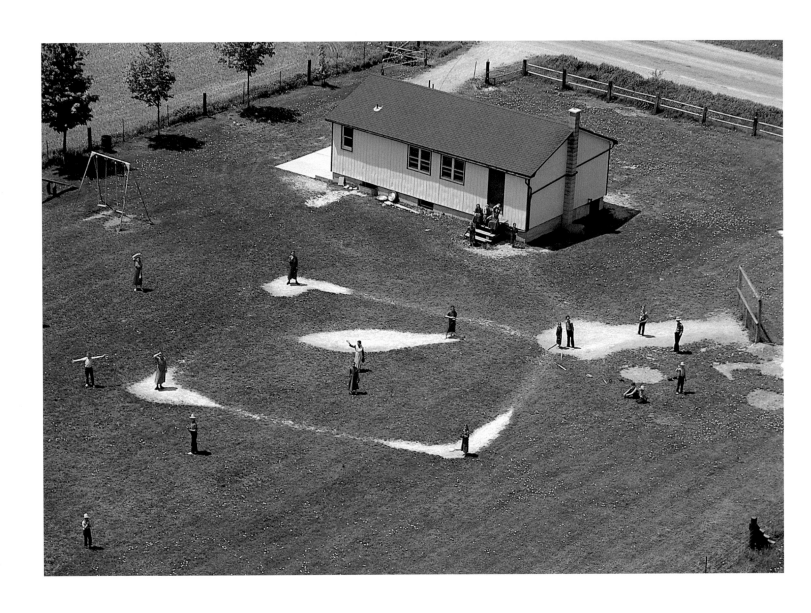

A childhood on a conservative Mennonite farm speaks of another time. You won't find televisions, radios, designer clothes or Nintendo games. Formal education ends at age fourteen, summers are spent barefoot, and bathing happens on Saturday night.

Mennonite children are allowed to be children. Beyond completion of a few chores — children as young as four gather eggs and wash dishes — most summer days are spent in play, and the games played often mirror daily Mennonite life. Junior grades play "horse" at noon hour. With a few feet of used binder-twine serving as reins, drivers gallop their human horses across the schoolyard. There are no rules. They crack imaginary whips and tie their horses to fenceposts as they visit imaginary stores. At the end of a pretend day, the horses are parked next to each other in an imaginary stable. The horses are equally imaginative. Some paw the ground restlessly, some pretend to eat grass, and on occasion, one breaks loose from the carriage and races to freedom. Drivers yell for help in nabbing the escaped animal in the corner of the yard.

Baseball is a favorite Mennonite game, and its interpretation speaks volumes about community values. When teams are chosen, everyone is chosen with equal enthusiasm. Bats often come from Dad's shop, turned out on old lathes. They may be lopsided, too long and too heavy, but everyone has their favorite. Tattered balls fly through the air, some worn down to their inner core. Runner and ball fly toward first base and arrive in the same instant. Is she safe? Anyone, including the runner, may make the call. And there's no dispute! In junior grade games, the pitcher lobs as many pitches as necessary until the batter finally connects. Most amazing is that no one keeps score. This is play for the sake of play.

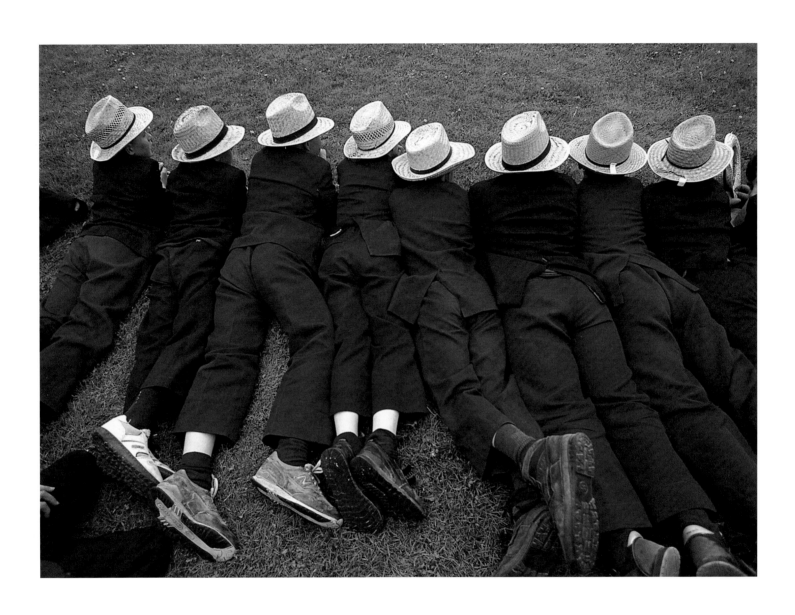

According to teachers in the Mennonite schools, most Mennonite children are a joy to teach. Because they are introduced to chores at an early age, they have a strong work ethic that spills over into their schooling. Assigned to a task, they'll stick with it until the job is done. Misbehavior in school is the exception, but when it does occur, it is easy to deal with. At every level in the community, there is respect for authority. Parents support teachers, and one of a student's worst fears is that he or she will be sent home with a note. (When one Sunday-morning sermon made reference to a student behavior problem, several parents called the school to ask if their children were the concern.)

The overall Mennonite population is a complex one, with over twenty Mennonite sects found in Waterloo County alone. I have chosen to focus on two groups, the Old Order and Dave Martin Mennonites, both often referred to as "the horse-and-buggy Mennonites." Readers may notice subtle differences in dress and hair styles between children from these two groups. One obvious distinction exists in their schooling. Since the mid-1960s, Old Order Mennonite children have attended their own parochial schools, with eight grades typically in two-room schools. In contrast, Dave Martin children have remained with the county schoolboard system and are integrated into existing classrooms.

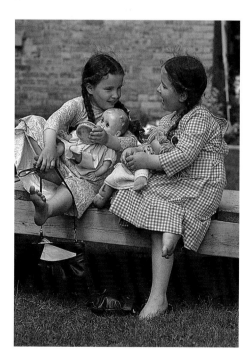

In the final shaping of this book, I chose not to identify any of the individuals featured in these pictures or stories. It has been a fine dance for me, wanting this book to be detailed and filled with local flavor but at the same time wishing to honor the people's implied request not to be singled out or glorified in any way.

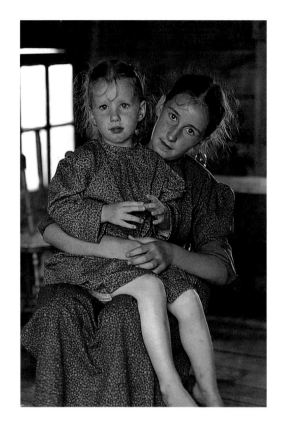

I also faced a quandary as to what words would accompany the photos. I did not want the book to contain only my words, filtered through my unknowing eyes. I sensed that I could best capture the flavor of these people's lives by finding *their* words. But when I approached the children with personal questions, I was met with surprising silence. They were not used to talking about themselves, particularly to an outsider.

I wondered, did the children have written stories? Did they have composition books from previous school years? Would they share them with me? I was delighted when boxes were located in attics and dog-eared scribblers began to arrive. Most stories were fiction, but on occasion I discovered a "keeper," a true-to-life anecdote that spoke of who these young people were.

Could I take this one step further? Was it possible that the children might write around specific questions? Armed with a mock-up of my book, a page full of questions and a cautious intent, I approached teachers in the parochial schools.

In the next several months, a huge window opened into this community as I was generously given dozens and dozens of stories. Even adults shared their childhood memories. I wish there were space in this book to publish many more.

In addition to the pictures and the stories, these children have given me some very special memories. One blustery Saturday afternoon, I spent a couple of hours with a group of children playing in "the shop." Phares came in from outside and commented that he'd seen a

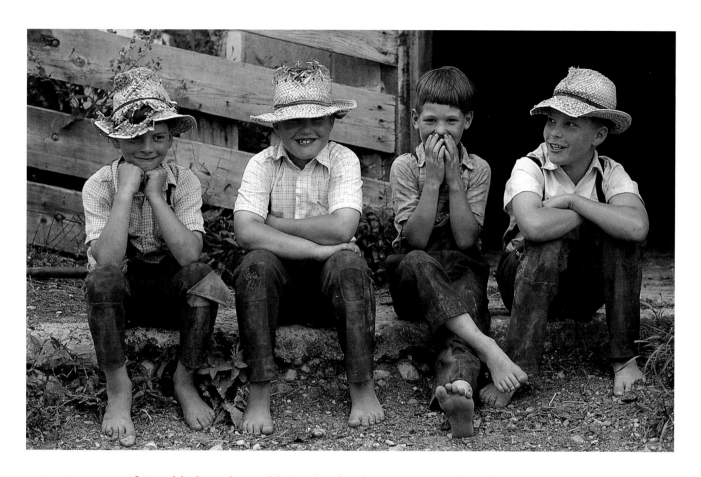

guitar in my car. If I could play, why couldn't I play for them? Fair enough, I thought, and soon we launched into a hearty session of folk tunes and hymns. We knew many of the same songs — Mennonites of all ages love to sing. In a lull between songs, nine-year-old Matilda turned to me and said, "Well, Carl, if you hadn't had your accident, would you still be our friend?" I was dumbfounded by her insight. In the silence that followed, I reached deep to find a truthful answer.

"That's an excellent question, Matilda," I finally replied. "I think you're right. If I hadn't had the accident, I'd be too busy, and I'd be somewhere else. But I'm glad I'm here."

## WHAT MAKES ME HAPPY

It makes me the happiest if I do the right

things, such as being kind, helping others,

not being selfish, to not argue and

to be satisfied with what I have.

These things make me the happiest.

boy, 11

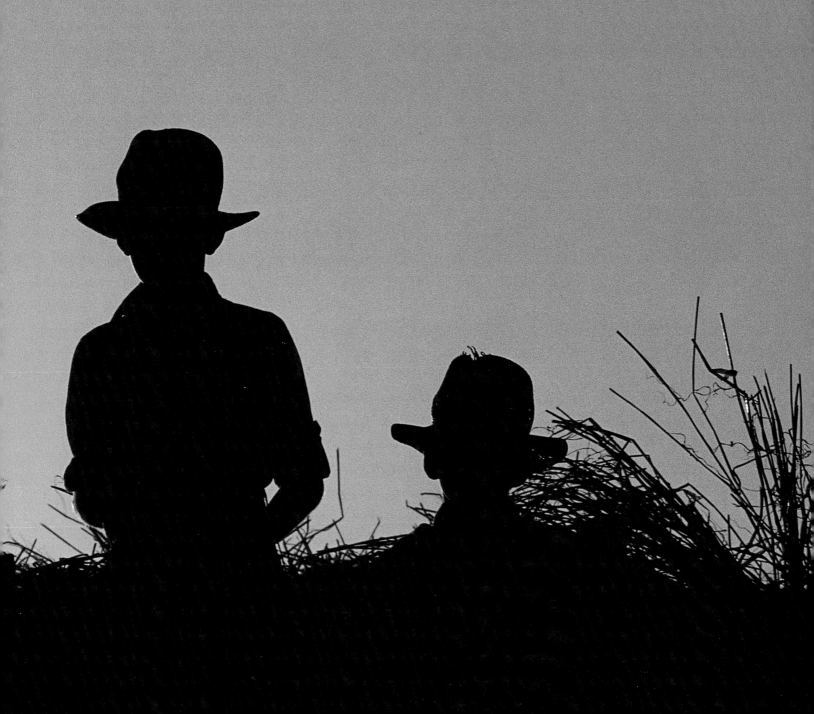

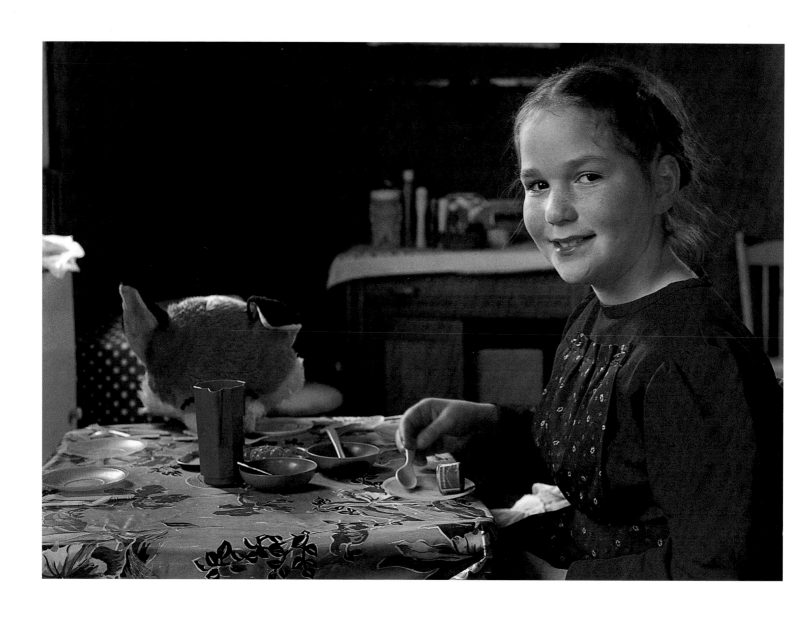

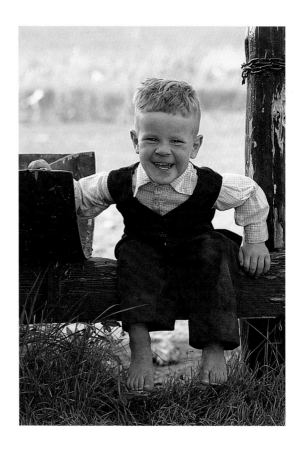

## MY DEAR FAMILY

My family members are all very dear to me, and I don't think Christians should show partiality, but if asked I would have to say my parents are my favorite family members. Maybe it's because of the infinite love they always surround me with. Perhaps it's because they are the ones who cared for my needs from infanthood.

I enjoy immensely the times in winter when the days are shorter and everyone has time to relax around the kitchen at the close of the day, before retiring to bed. How blessed I feel when I see my father take the time to look at a book with my three-year-old brother when everyone else is too busy reading. Thank you, God, for my loving family.

*girl, 12*

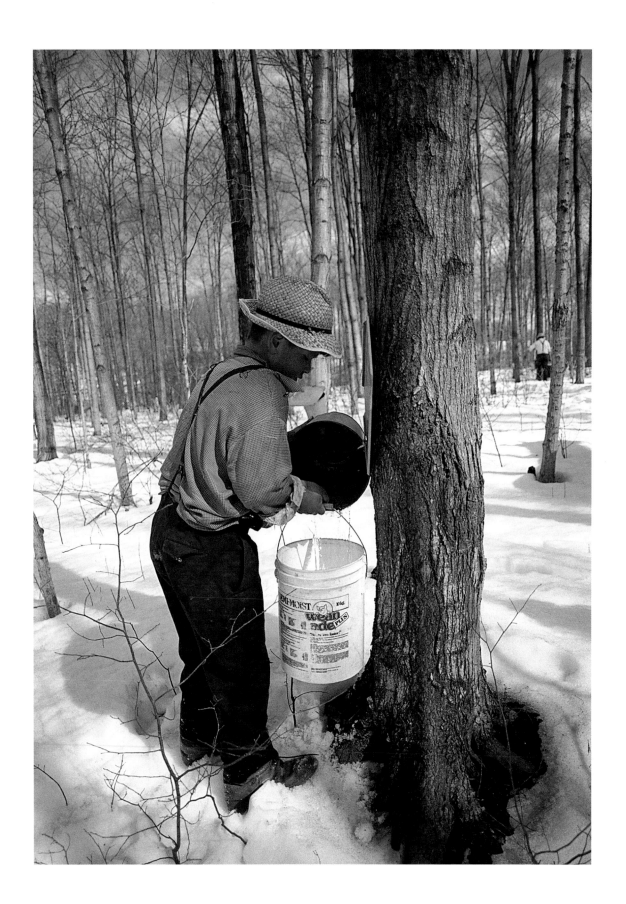

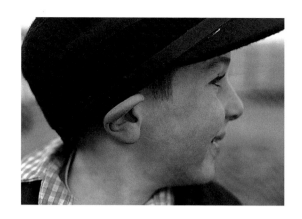

## MAPLE SUGAR TIME

Maple sugar-making in the spring is always fun. I help gather the sap, dump it into the tank, splash some over myself, then get another pail full. I love trampling around the snow and I like the sound of sap dripping into the pails. It gives me a happy feeling to help with the work.

When all the sap is gathered into the big tank, we pump it into the shanty, where it is boiled. The sap shanty is always full of steam. As the sap gets hotter, it slowly turns a golden color. When it is half maple syrup you can take some out of the evaporator and cool it till it is just warm. Then you can drink it till you can't hold any more.

boy, 9

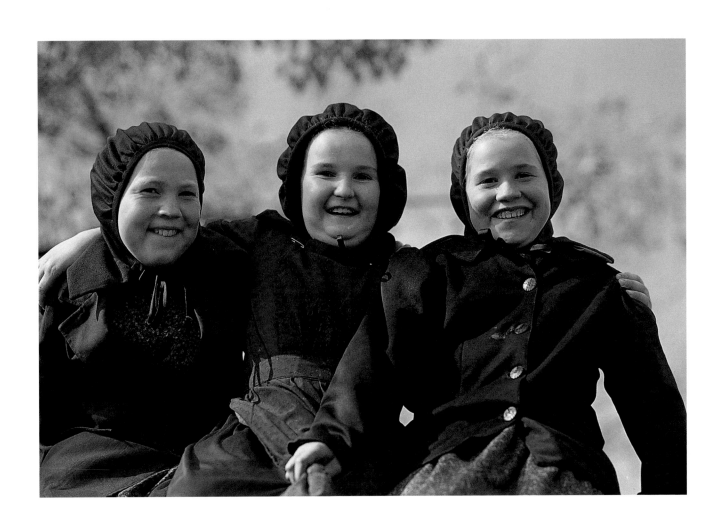

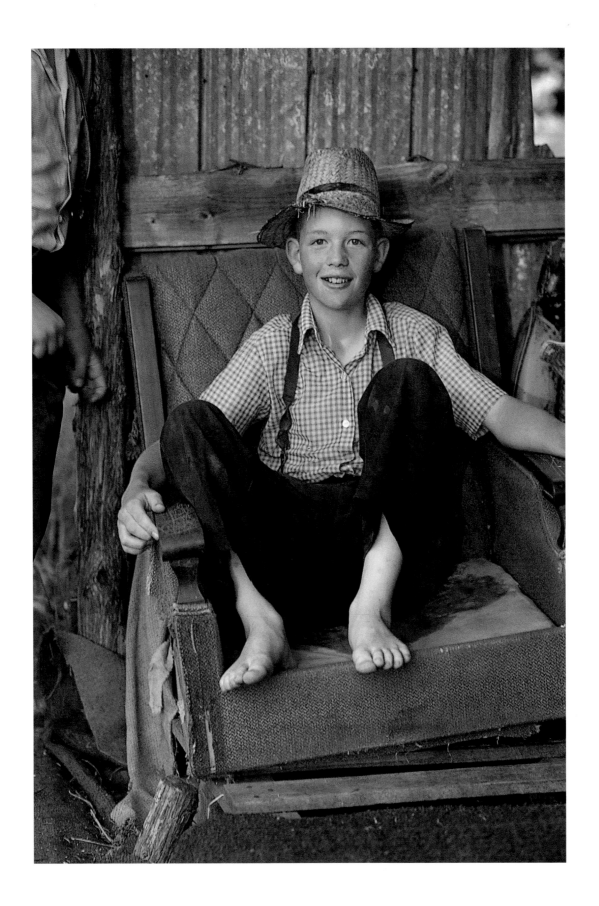

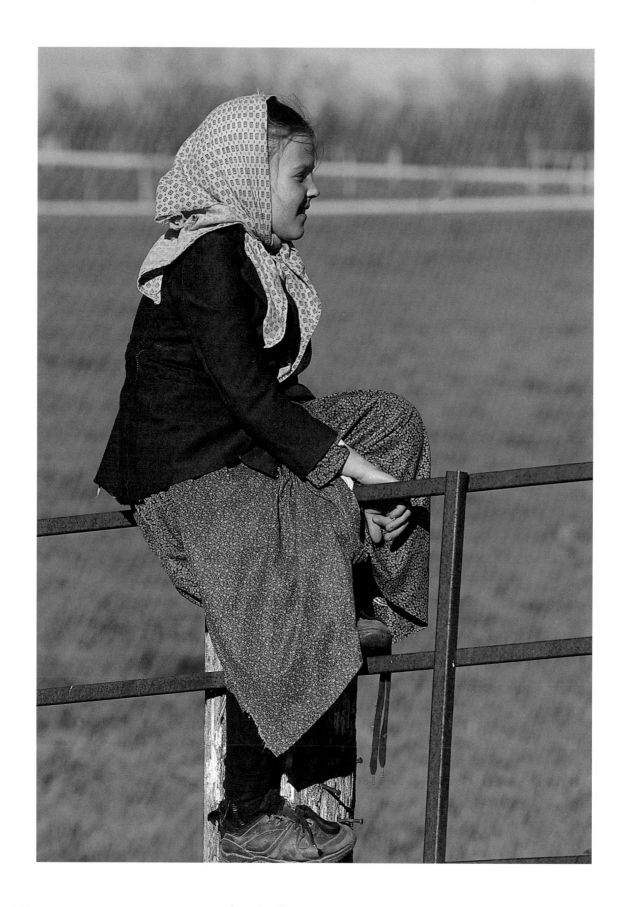

## THREE WISHES

If I could have three wishes come true, first I would wish that Ruthann could walk. She is a twelve-year-old girl who has been crippled since she was born. Then I would wish that Louella and Lucille would be able to hear. They have been deaf since they were born. I wish they were able to talk and hear when others are talking. Last of all, I would wish we could make scrapbooks and go singing for shut-ins, to brighten up their cold winter days. I would like to do this with my school friends. We would make cookies, cards, and also get a lot of old pictures — maybe even pictures from their childhood.

It would make me happy if these wishes came true because I know these people would feel happy and thankful. I think even though they are crippled or deaf or handicapped, they still want to be useful like us. We have so much to be thankful for.

*girl, 12*

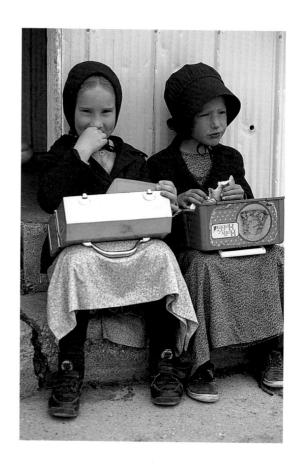

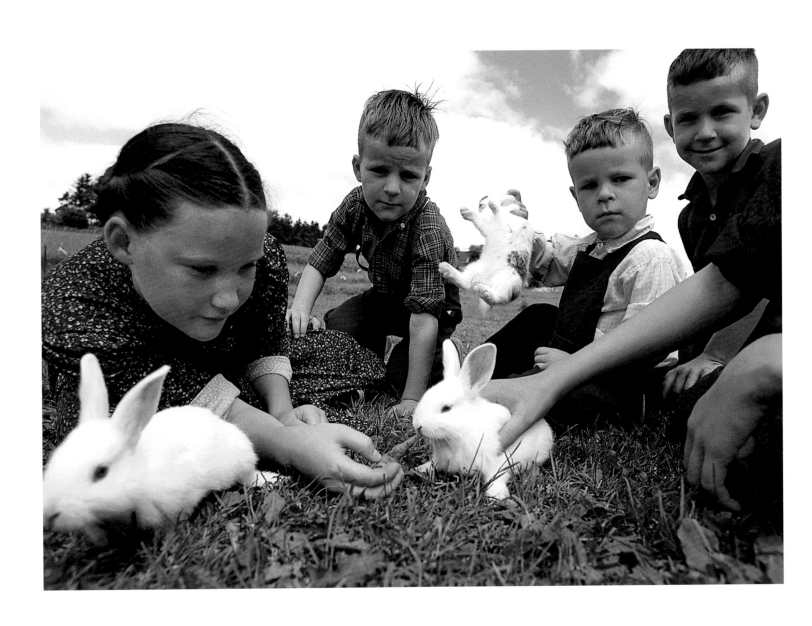

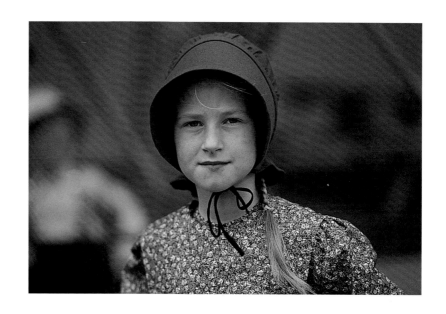

## WHEN I GROW UP

When I grow up I hope to be a mother. I would like to get married at the age of twenty and have about eight children. We would live on a farm with forty-five cows and some sheep and rabbits. As I grow older, I hope to sew pants, shirts and dresses, and bake cookies and squares, and best of all, make some delicious cakes.

As I grow older and become a grandmother, I hope to be able to make thick blankets, coats, sweaters and thick woolly socks for winter, and some thinner clothes for summer. I will sell them at the Stockyards and use the money to buy groceries for the poor. Oh, how fun it will be to grow up.

*girl, 11*

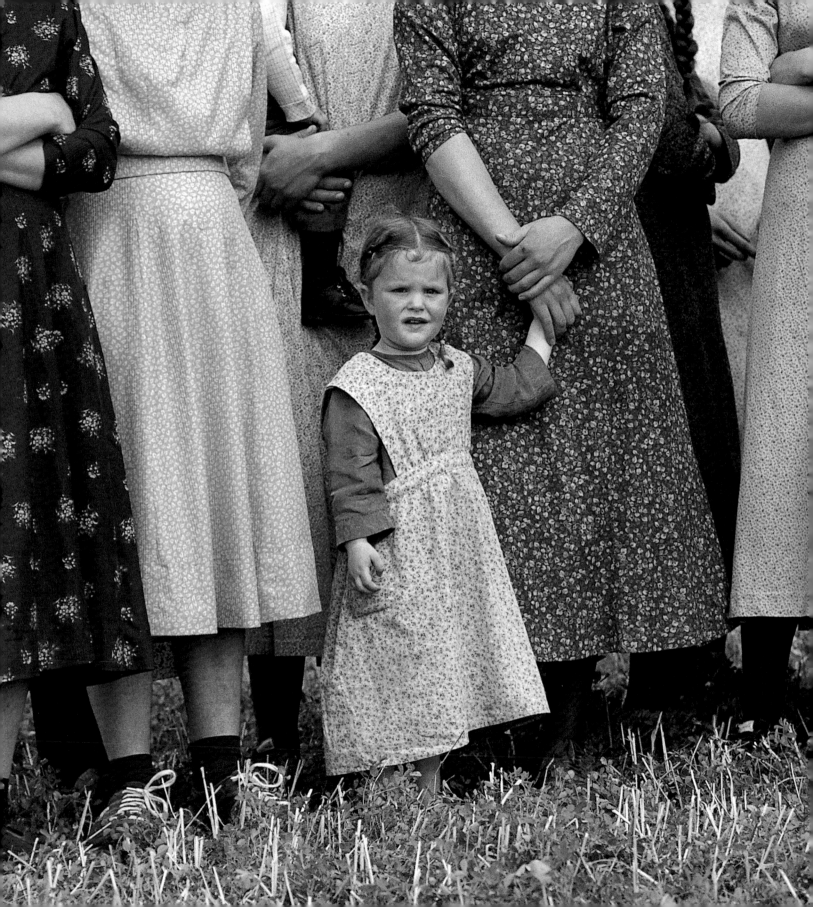

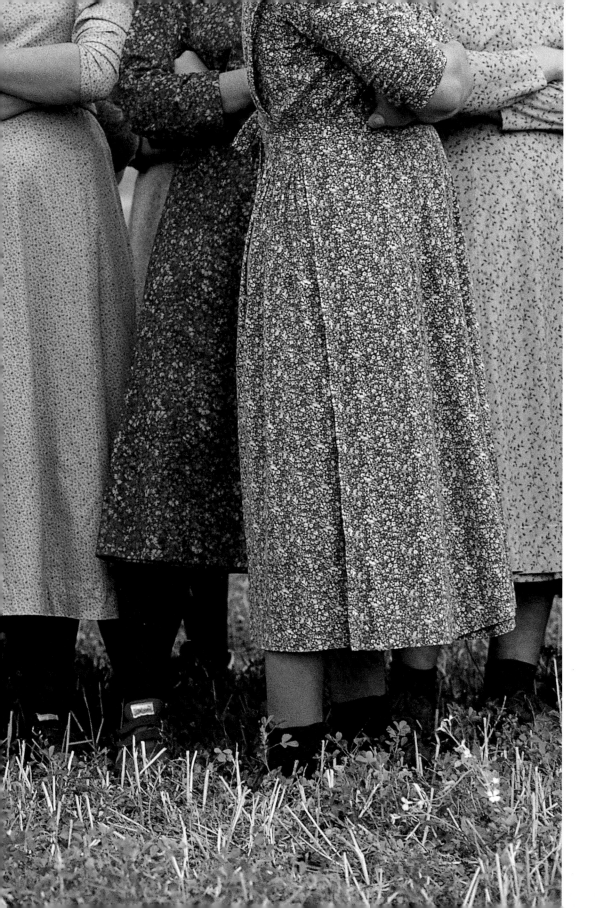

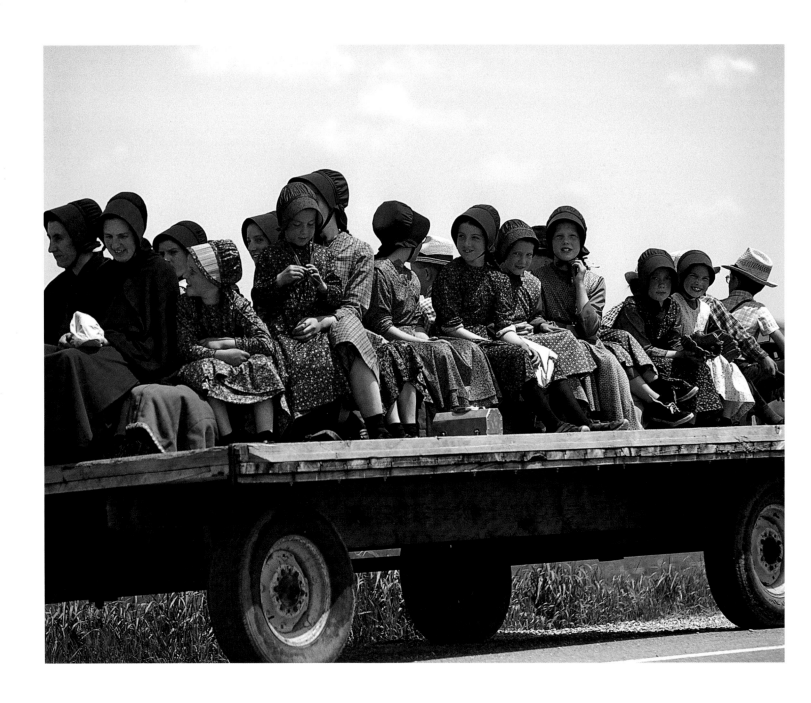

## THE FISHING TRIP

When my mom called me, I jumped out of bed and ran downstairs with my four brothers trailing behind me. We were excited because we were going on a fishing trip. We munched down a quick breakfast, then helped with the morning chores. After chores, Mom braided our hair, and my five sisters and myself all changed out of our everyday dresses and into our school dresses. My brothers got their fishing poles ready. We had already dug up worms the night before. We, all ten children, climbed on the wagon while Dad got the two horses.

The air was brisk but the sun was shining as we drove along the gravel road. We finally turned into a lane and tied the horses under a shade tree. We all scrambled off the wagon and ran to the river and cast our lines in. By now I was really worked up. The water was so clear you could see the fish swimming around. All of a sudden my brother Stewart got a tug on his line, and my mom got really excited. Stewart's pole really bent. The fish was a carp, and was it ever big. It was approximately an arm's length.

We tried fishing again in some other places, and one by one we did get fish. Before I realized, it was time to go home, the afternoon had gone so fast. Once again, we all piled on the wagon and home we went, with the carp and the six pike we had caught. Boy, did those fish ever make a delicious meal for us.

girl, 11

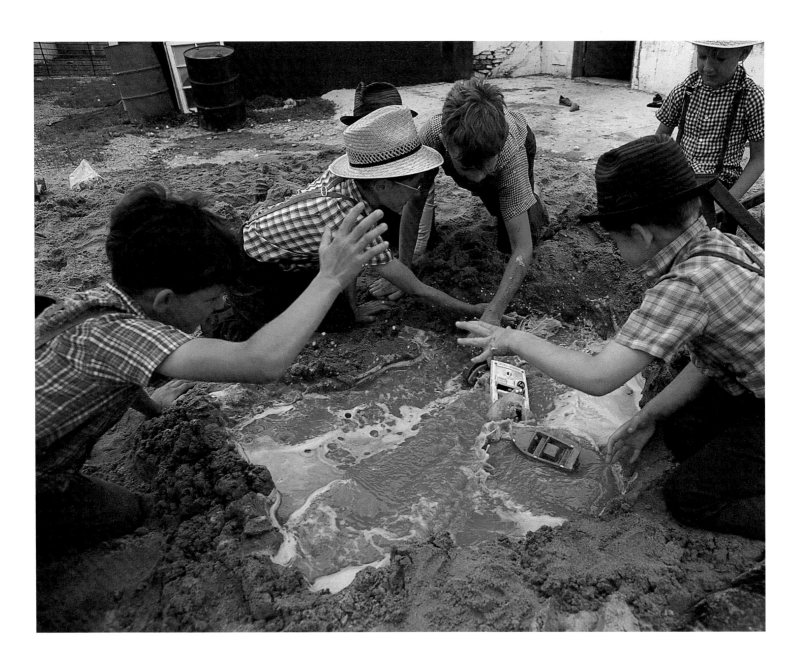

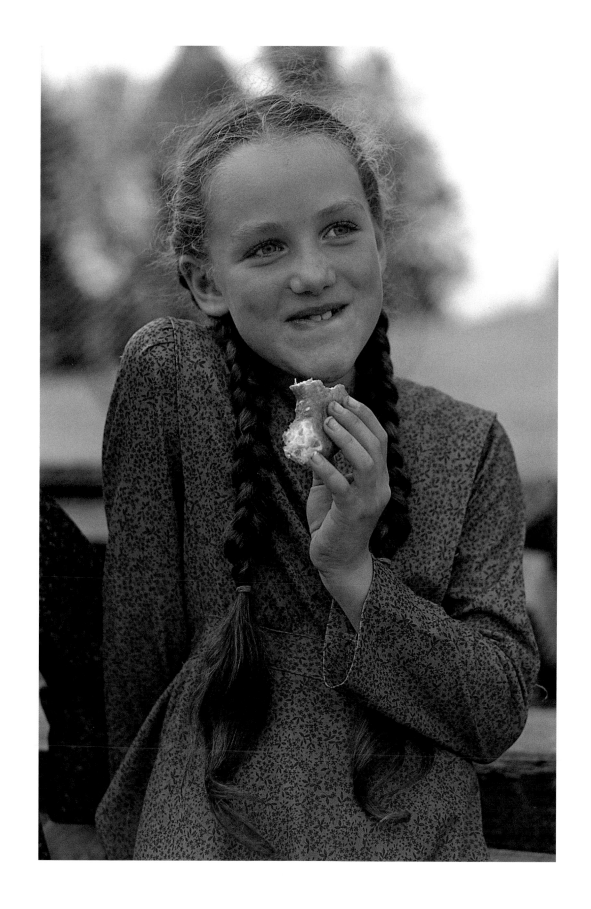

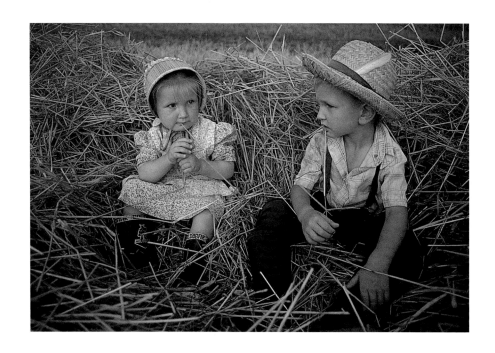

## THE HORSE AND THE BRAID

The funniest thing that I have ever heard is about a horse that bit off a Mennonite girl's braid.

I imagine that she was just walking past a horse, and the horse decided the braid looked delicious.

Then, for a while, she had just one braid. But now she is a grandmother with no braids. She still has

the braid that the horse bit off. I sure hope that a horse will never bite my braid off!

girl, 12

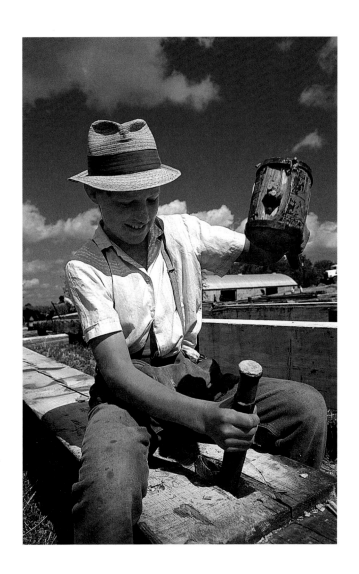

## IF I HAD A HUNDRED DOLLARS

If I had a hundred dollars to spend, I would build a shop and buy tools and start making things, like benches, pony carts and little tables. I would walk around the streets selling my things. When I made enough money, I would buy a pony and harness and make a cart for it and use it to sell my things. Then most of the profit I would make would go to the poor people.

boy, 10

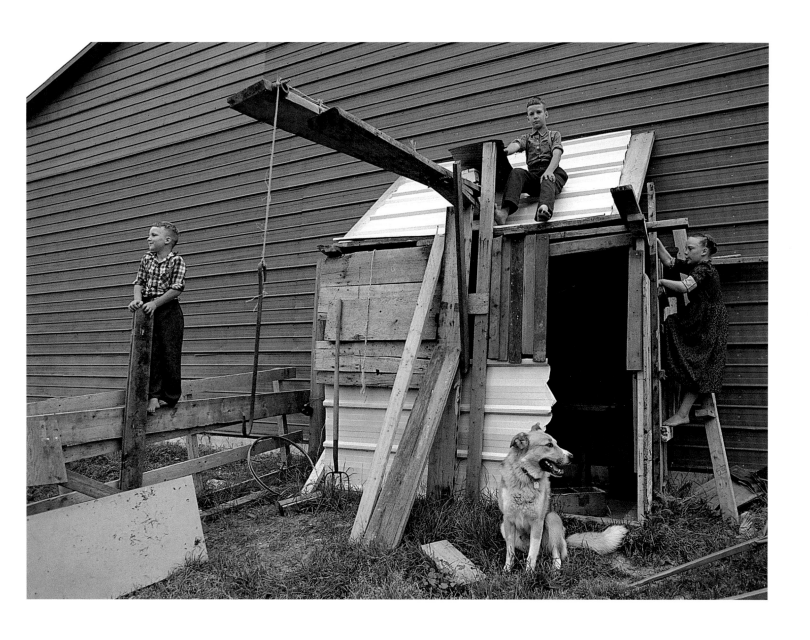

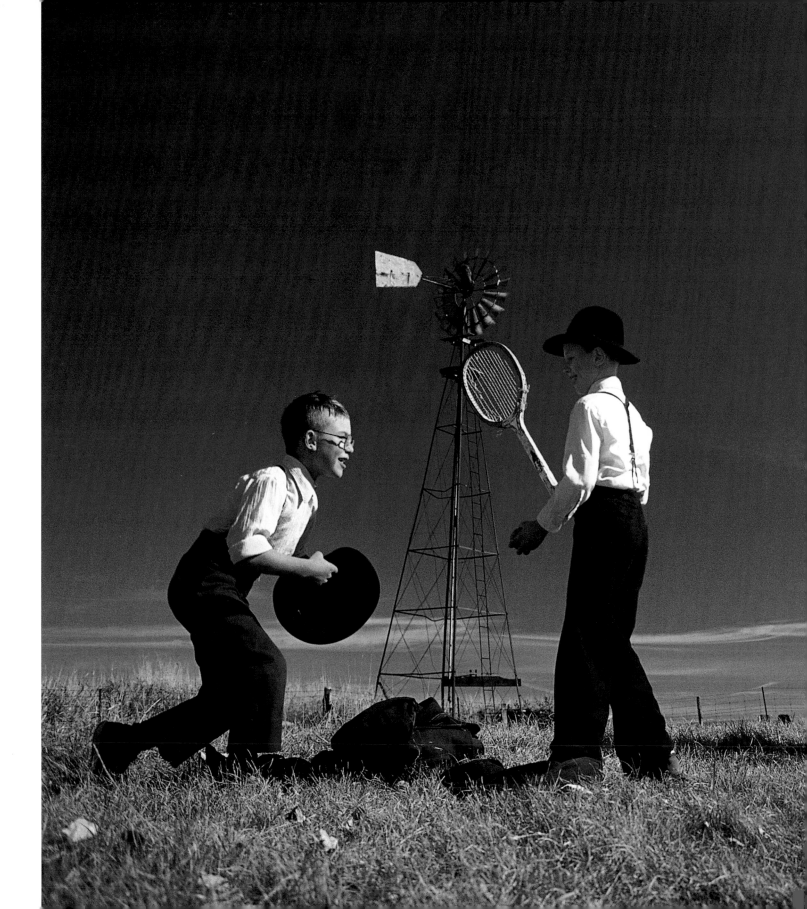

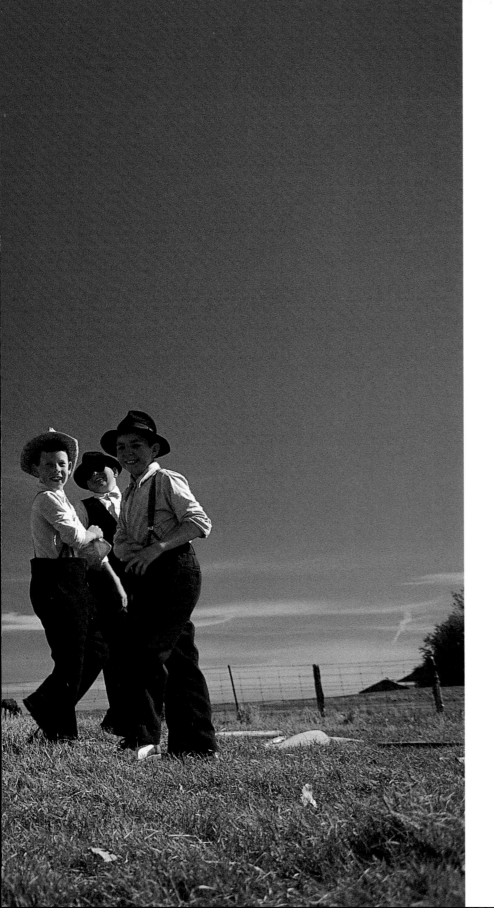

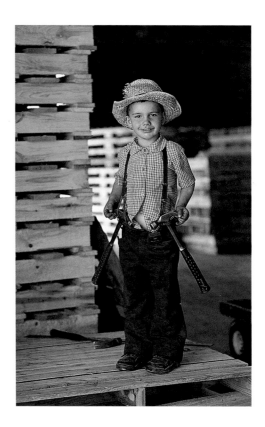

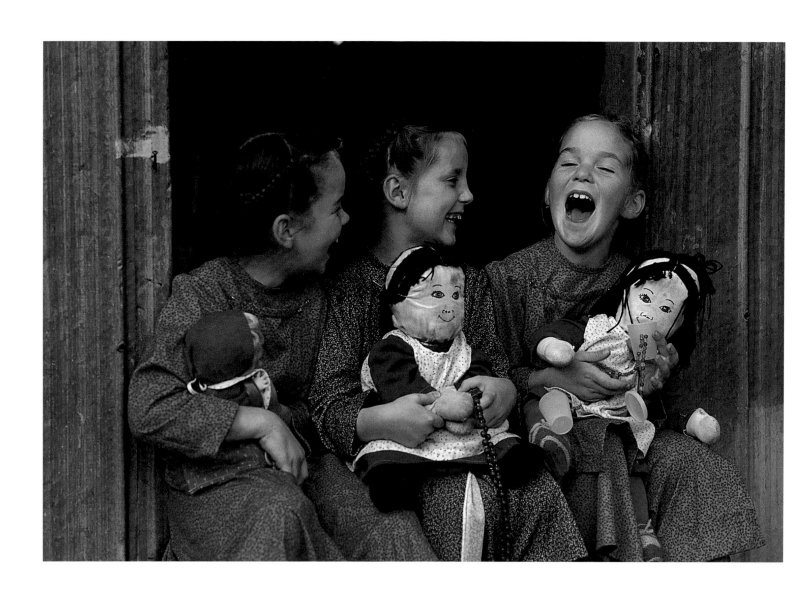

## WASHING DOLL CLOTHES

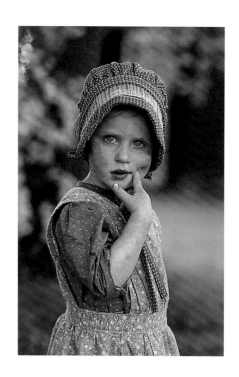

I am eleven years old, and my sister and I like to play with our dolls. My mom got some dolls from the store, but my mom's friend makes dolls, and we bought four dolls from her. My dolls' names are Maggie, Melinda, Annie and Betsy. My sister names her dolls, but she always forgets them and gives them other names.

One Saturday I decided my dolls' clothes were too dirty. My mom said it was okay to use the washing machine. I put the clothes in the water and pulled a little knob and the clothes went around like rockets in there, but all you could hear was the water splashing. Then I turned another lever and the wringer started. I had to fish out the clothes with a wooden stick and push them through the ringer. After that, I hung all the clothes on the line. When I was finished, guess what I saw? A clothesline and a half full of little dolls' clothes. What a sight, I thought, people driving by must think we have a *very* small family.

girl, 10

## DEAR CARL HIEBERT

The day you took me on a plane ride is a day I shall never forget. I set my alarm clock for 6 A.M. so I could do my chores and be ready when you came. That night I suddenly awoke and my alarm clock was blinking and saying the wrong time. The electricity had gone off while I was sleeping. I took my brother's alarm clock and my pocket watch and my clock and set them all on the dresser. I did not want to miss this ride. The next morning I was disappointed because it was foggy, but I did not give up. While I fed the cows, many questions filled my mind. Would I get sick? Would I throw up? Would I have a stomach ache?

My questions are now answered. My ride with you was wonderful. It felt absolutely cool and smooth. I felt like a bird soaring in the air. I am very glad you showed me our farm. You showed me

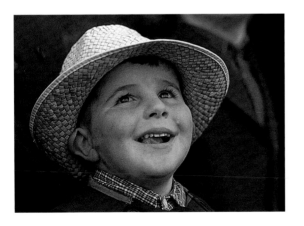

every corner of it. There is no better place to look from except a plane. I loved the sound of the wind, the comfortable seat, and the powerful roar of the motor. I had often wondered how a bird feels in the air. Now I know, because I almost felt like one. I shall never forget the feeling when the plane lifted off the ground. Everything looked different. The buildings looked small, just like toys. I felt free and relaxed, like an eagle in the air.

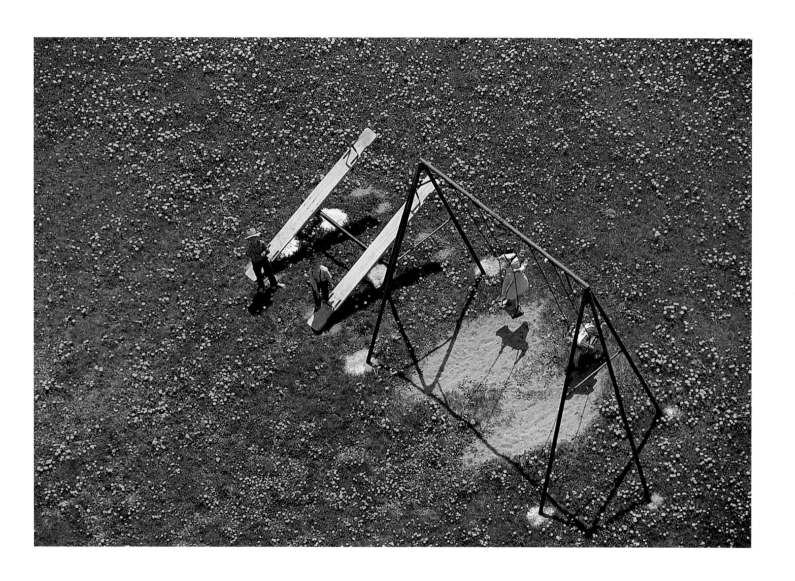

Every time other people or you flew past, we all ran out to see your plane. I never

expected a ride and didn't know what it would be like, but now I know and I think it is the best

way to get around in the country, the best way to look around and enjoy the morning breeze.

boy, 14

## MY FAMILY

I like my family. I have three sisters and one
brother. Yesterday was Sunday and we were
at church. After church we went home and
soon it was time to eat. For dessert we had
ice-cream and other birthday things — my
mother's birthday dinner. Then we went for a
long walk to the river. When we came back
we saw seven geese on the ground and were
able to walk very close to them. Then we
found an apple tree and my father shook the
tree so the apples would come down. There
was a cow under the tree and it nearly ate the
apples, but we got them first. Then we went
home. We all had fun that day.

boy, 8

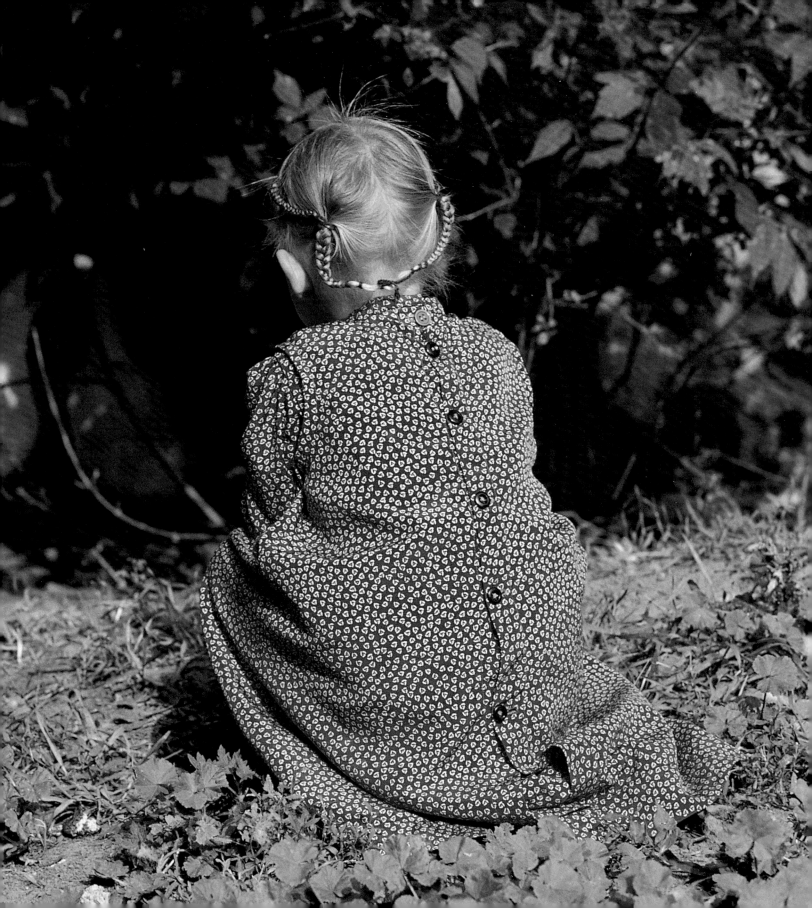

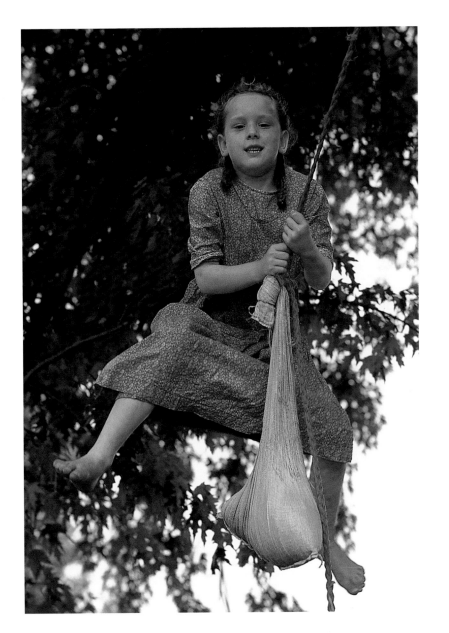

## THREE WISHES

If I could have three wishes to make,

I would wish for a trip around the world.

I would like to see so many different kinds

of scenery and many different colors of

people. My second wish would be that

there wouldn't be so many dishes to wash.

(There are so many dishes with ten

children in our family.) My third wish is

that I could run faster. It would be fun to

be able to sail over the ground.

girl, 10

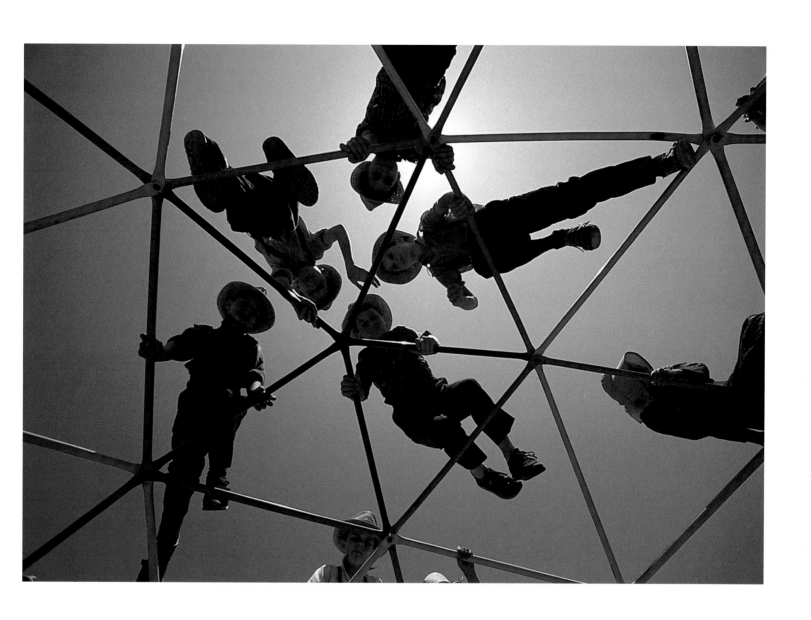

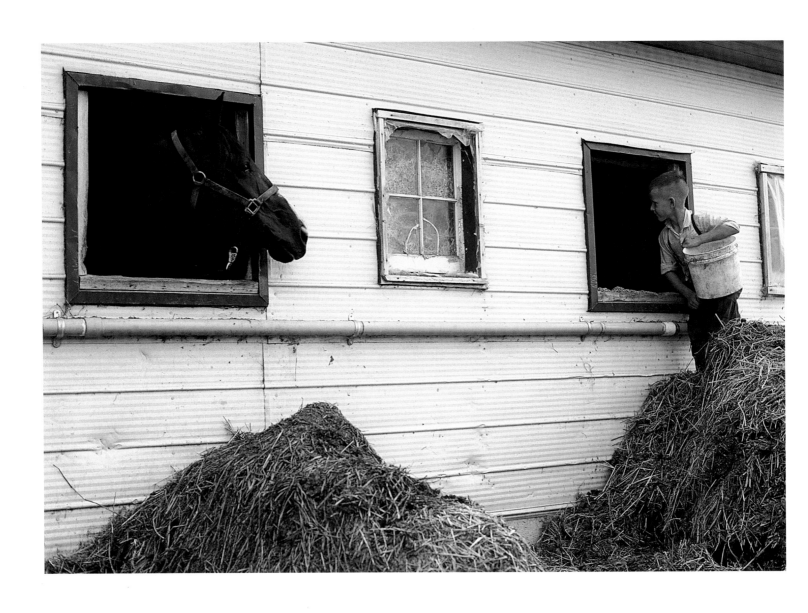

48

## HOW TO MAKE PEOPLE HAPPY

People are the happiest when they are kind to
one another. If you work nicely for your parents
and neighbors. If you work without grumbling
or being told twice. If you help your neighbors
when they need help, or play with their children.
If you help sick people that can't get out of bed.
Then you are the happiest.

girl, 12

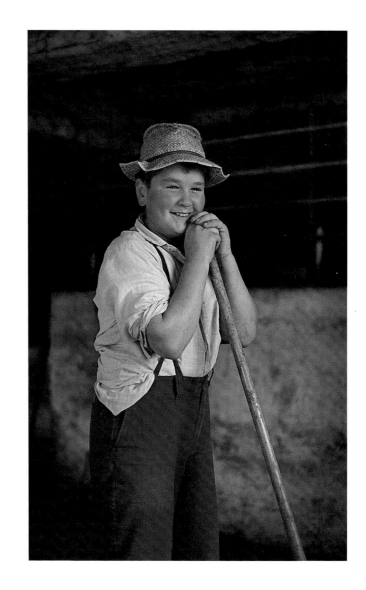

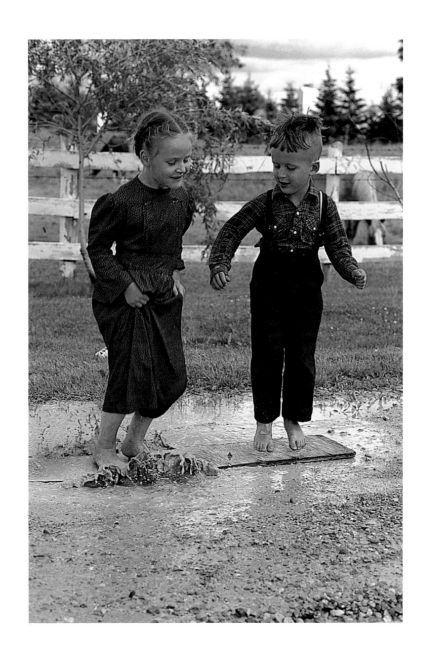

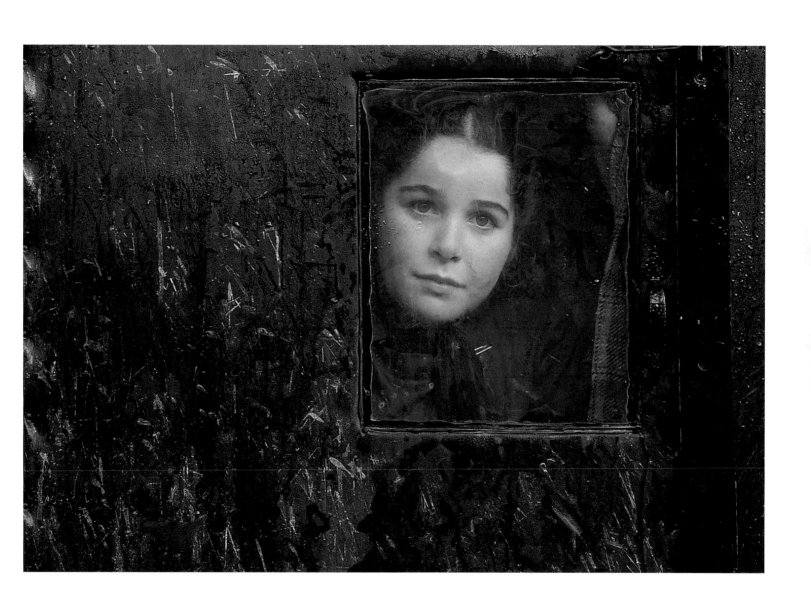

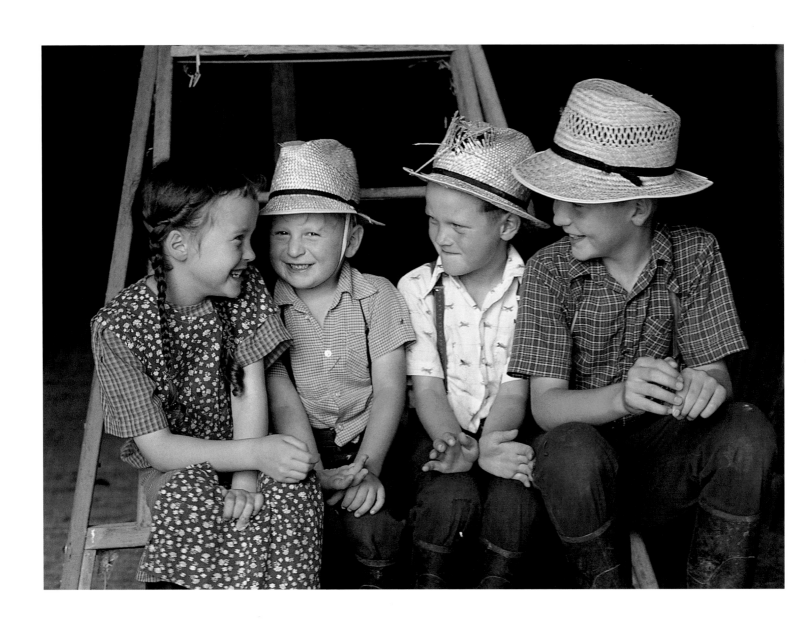

## HAPPINESS

People are the happiest when they are kind to one another. If you work nicely for your parents and neighbors. If you work without grumbling or being told twice. If you help your neighbors when they need help, or play with their children. If you help sick people that can't get out of bed. Then you are the happiest.

girl, 12

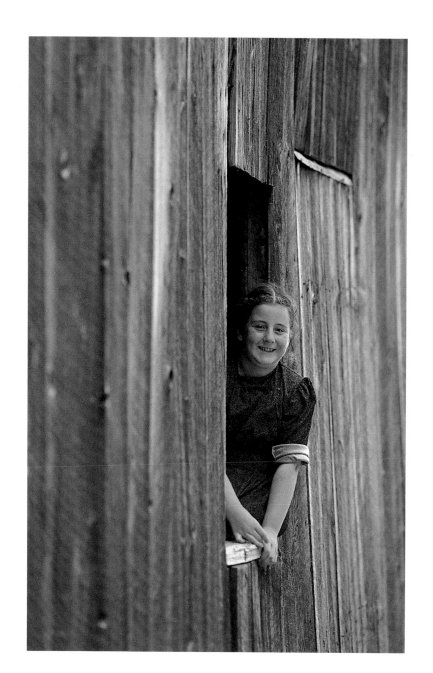

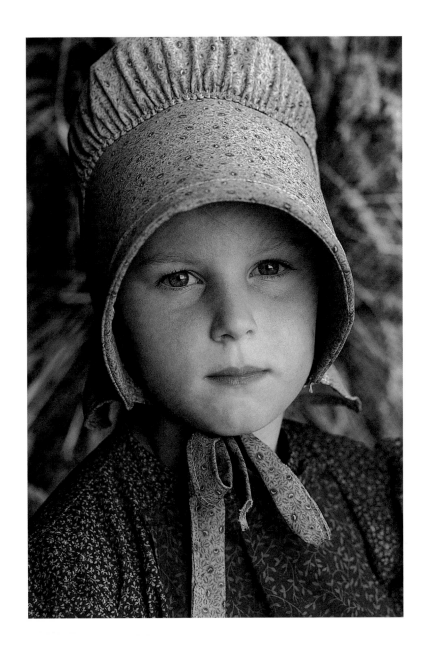

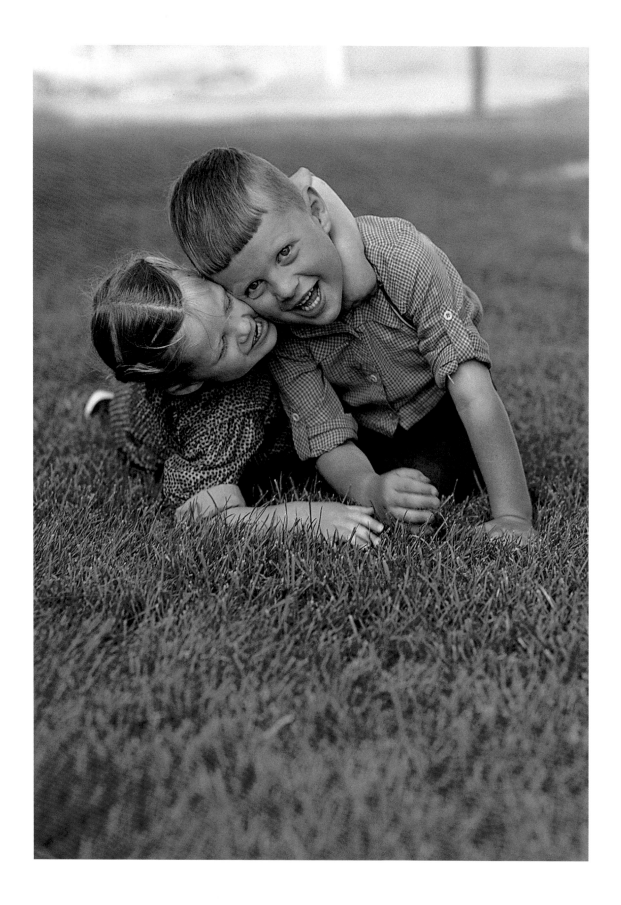

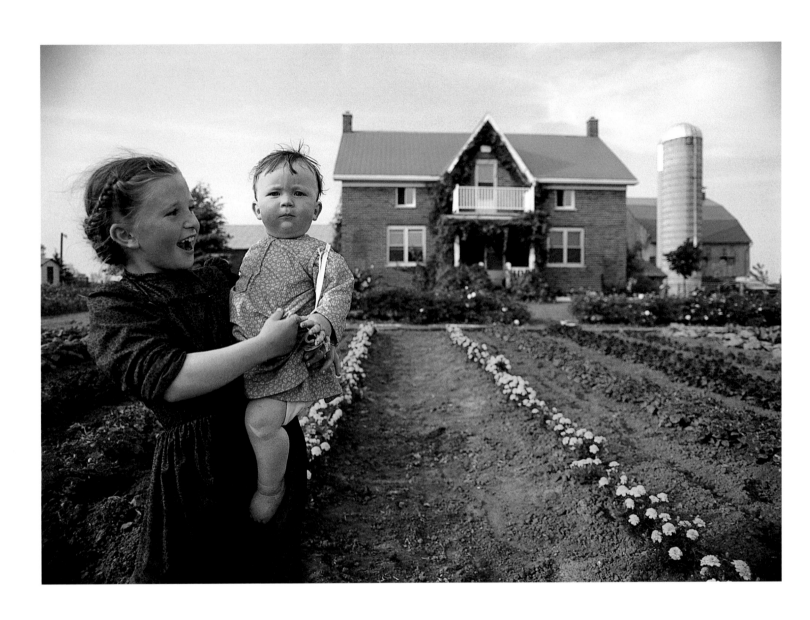

## A WELCOME SPRING

I look forward to spring, when it comes with its jolly robins, its sap season, its green budding trees and showy flowers, because it means that the summer holidays are not far away. The fresh green grass appears under the muddy snow, the trees burst into new leaves, and the birds burst into melodies all around. There are gardens to be planted in our bare feet. Suddenly baseball and haying season appear around the corner. Boiling sap on a little stove in the garden, in the starry nights, with flames dancing around, is another pleasure.

After thunderstorms everything is wet and refreshed and there are rainbows to enjoy. Animals frisk in the lush meadows, while birds soar high above. Waking up early enough to view the sun rise slowly above the horizon, when the calm atmosphere is broken by birds of all kinds singing at the top of their voices, is another wonderful part of spring. But best of all is the peaceful evening, after the work is done, when I sit on an old swing and watch the gorgeous sunset.

girl, 13

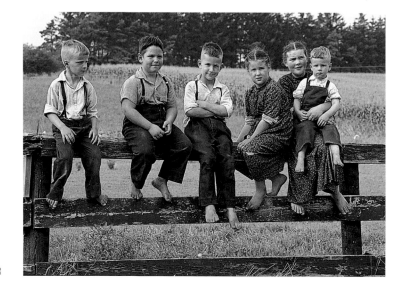

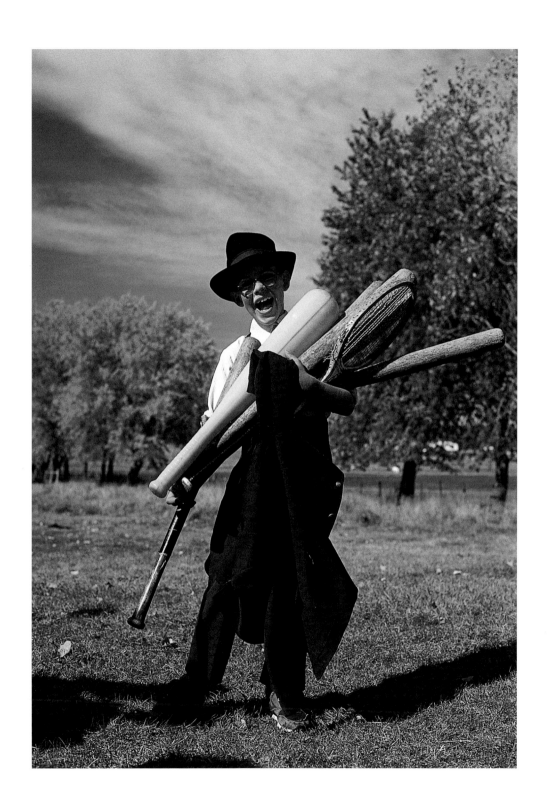

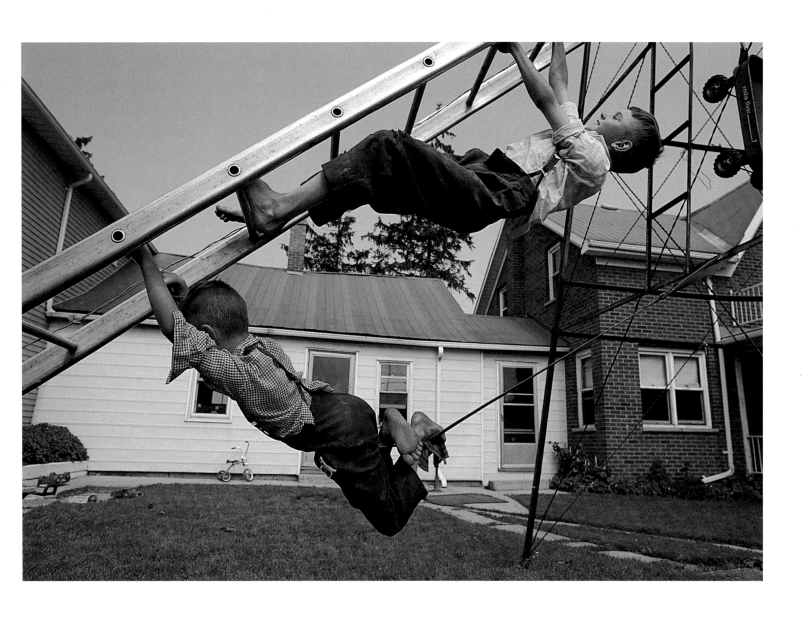

## THE NIGHT THE MOON

I'll never forget the night the moon followed me home. It's one of my first memories. I was probably only three years old at the time. We had gone visiting after church and stayed for the afternoon and for supper. By the time we started off for home, it was totally dark. It was a cool night and I remember being wrapped warmly in that little buggy seat in front of my mom and dad, facing backward toward the open sky. Home was several

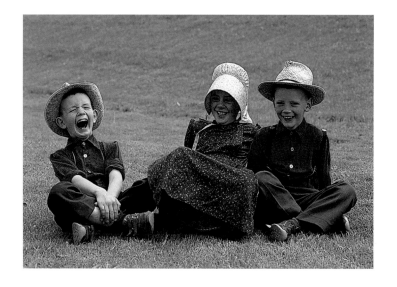

miles away and the gravel road twisted left and right through the corners. The strange thing was, no matter which way the horse turned, the moon followed directly behind us. As a child, I was quite amazed by this. How did the moon know which way we were going to turn? I never asked my parents about it, but I wondered about that smart moon for a long, long time.

man, 91

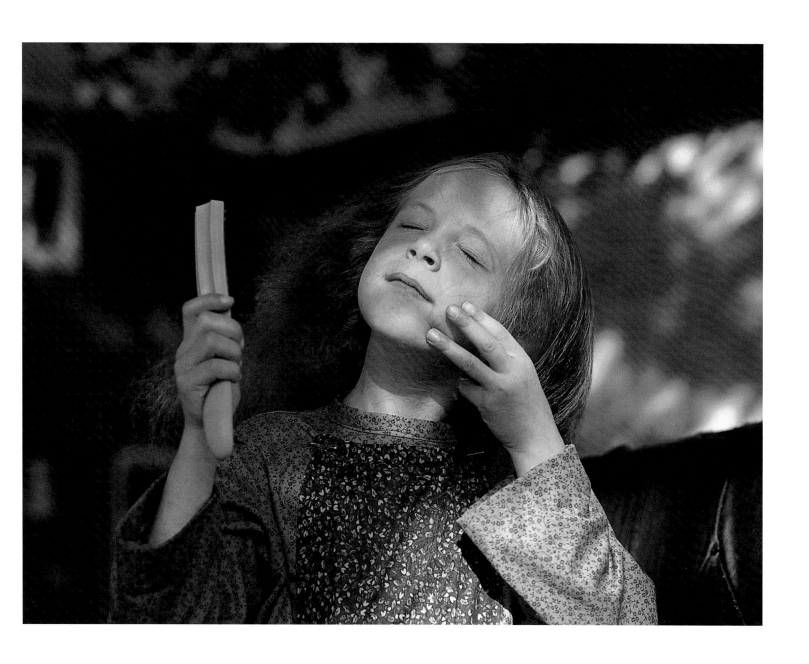

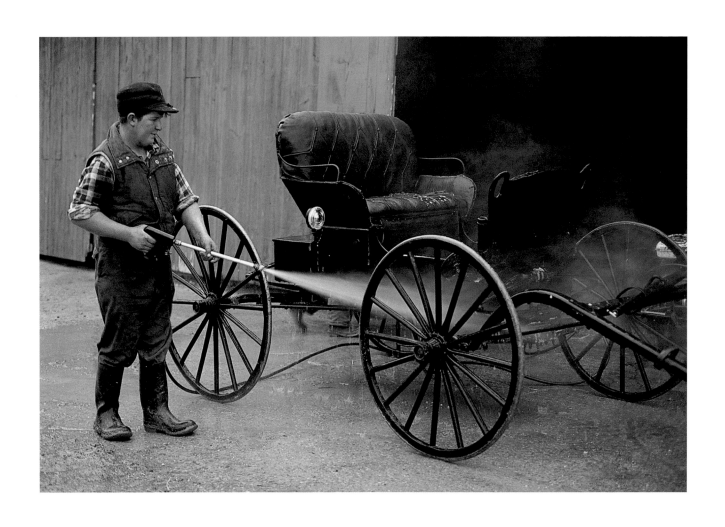

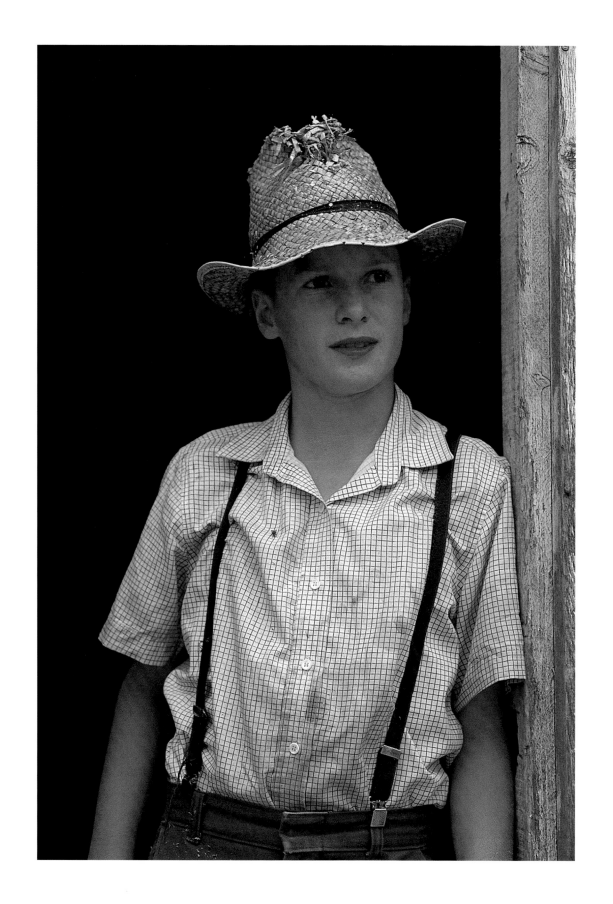

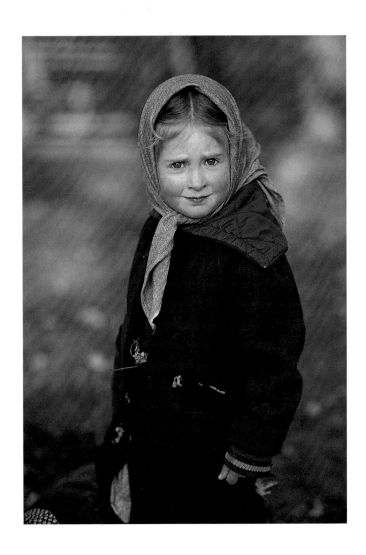

## A CHILD'S GARDEN

I planted my first garden when I just was six years old. My mom showed me how to do it. She helps me take out the weeds, but I water it with a pail. If it doesn't rain much, it needs lots of water. Mostly I grow peas, lettuce, corn, tomatoes and some flowers. It's not just for me; I share it with my family. My favorite is corn on the cob. First my mom boils it for about twenty minutes, then we pick it off with our teeth. It's good with Cheez Whiz or with salt and butter. Maybe the only thing I like better is pizza, especially with pepperoni and cheese and onions. It's good.

girl, 8

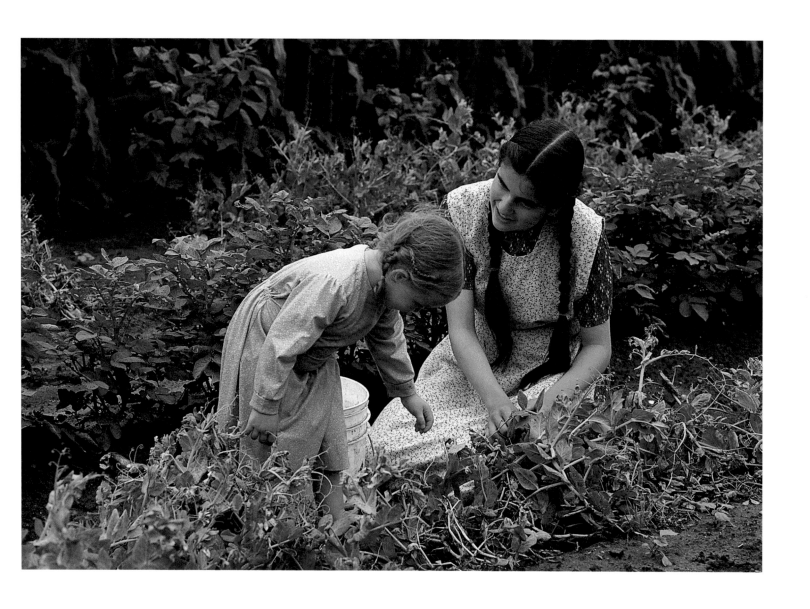

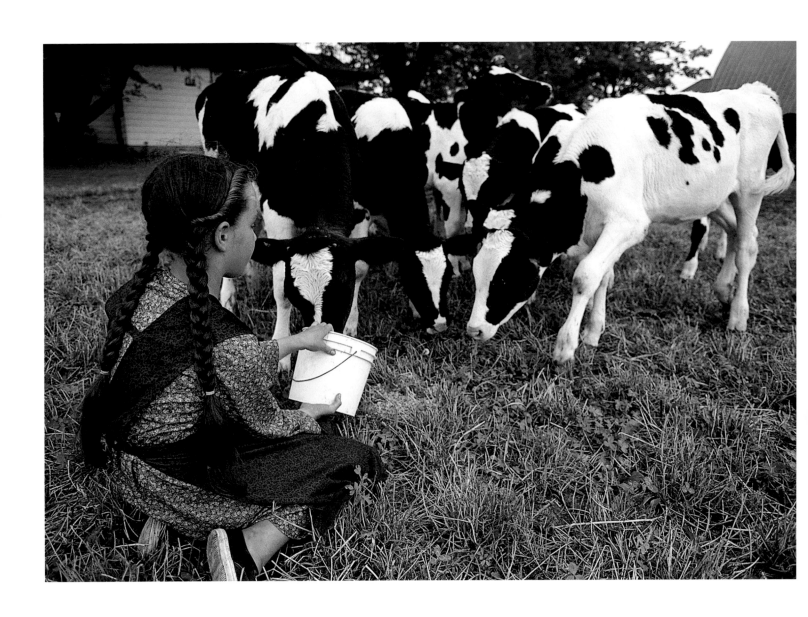

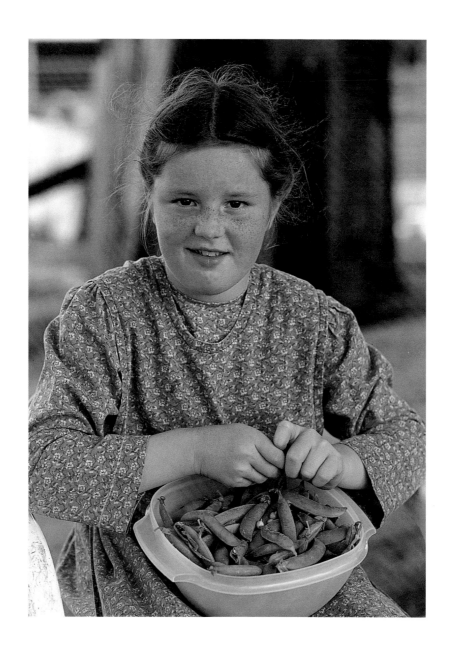

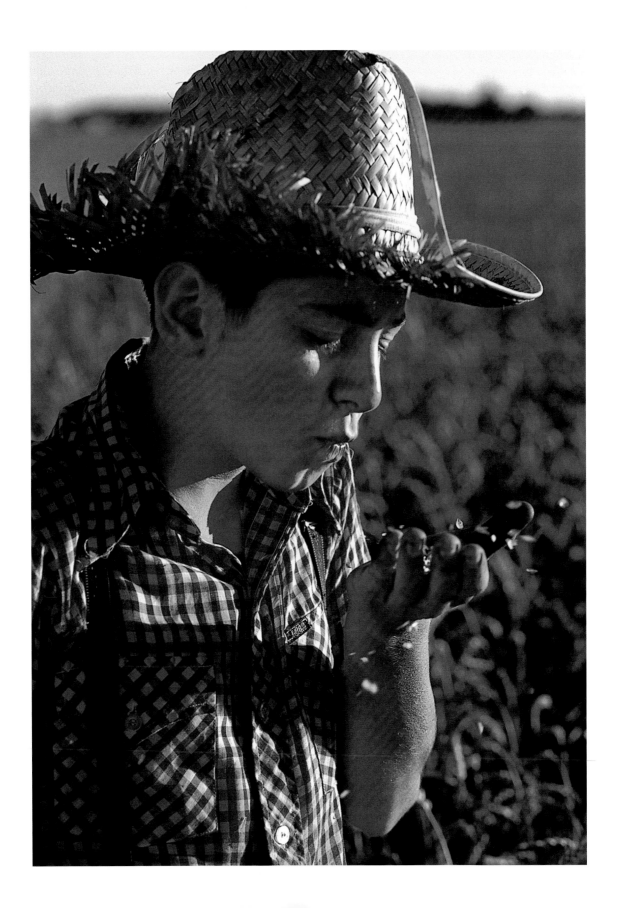

## WHAT I WANT TO BE

I wish to become a farmer when I grow older and bigger. First I will help my father with this work around the farm until I am about seventeen years of age. I will help in the fields, raking and baling hay, plowing, or cultivating. I will help to drive the corn or hay loads around. Then I will be a hired man for one or two years, for more experience. I might go hunting while camping by the river with my friends. I like to catch pigeons in the barn loft, feed rabbits, do other chores around the farm. Living on the farm always was a joy to me.

boy, 13

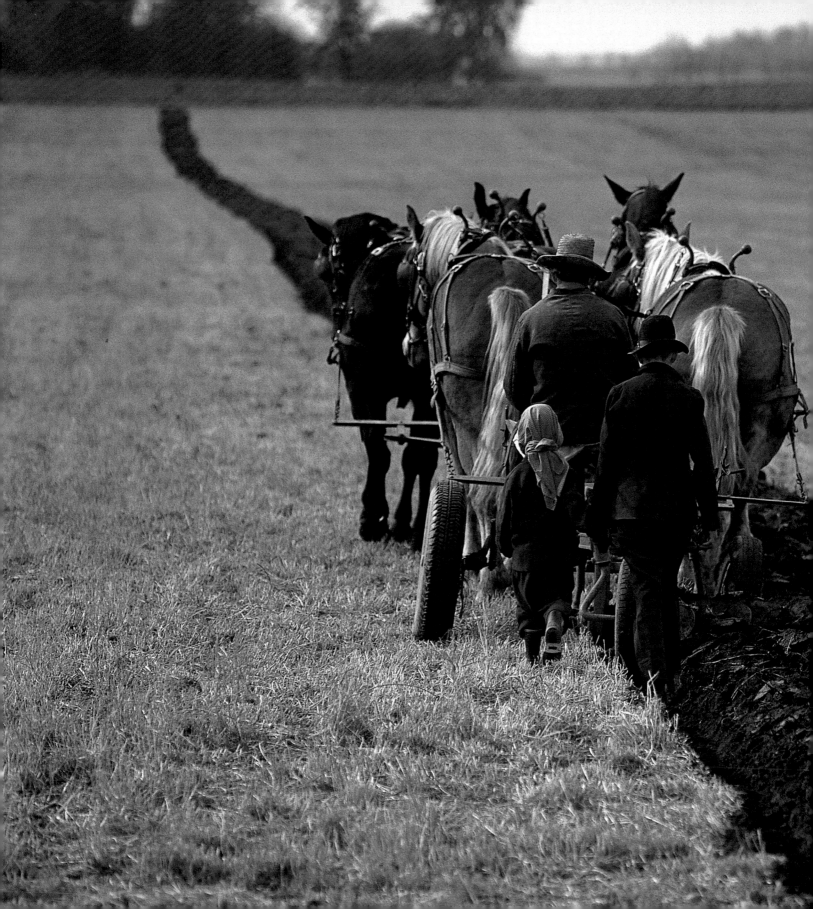

## A DAY IN WATERLOO

It was on a warm, sunny day that Dad took me for a checkup at the dentist. We went with the Hanover bus, so we had to be at the end of the lane at 9:30 A.M. When we got off the bus in Waterloo, I immediately felt very much out of place in this noisy, crowded and bustling city. As we walked to the dentist's office, I saw many strange people. After the dentist, we went shopping. How different it was from the quiet, peaceful life at home. I wondered what it would be like to live in such a noisy place all the time.

As we neared a big K-Mart store, excitement mounted inside me. I always enjoyed going to these *big* stores. I wondered what we would buy. Then we headed for the bakery

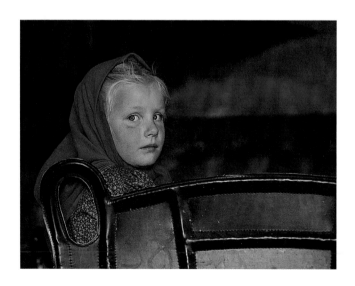

shop, and as we walked along, people stared at me from every angle. How good the bakery smelled. I almost forgot my nervousness until suddenly the door swung open and a group of children about my age trooped in. And how they stared! Even without looking, I could feel them staring at me. I wanted to run and hide, but instead I slowly edged behind a counter. How glad I was to be out of sight!

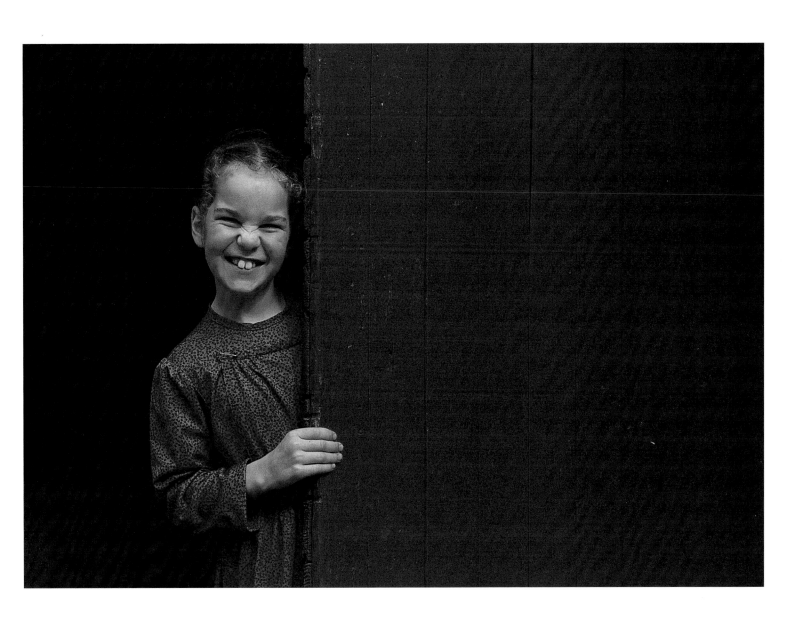

After shopping at a few more stores, we were at last ready to head back to the bus stop. I was very glad when the bus came and we could get out of that noisy, unfriendly place. I had an enjoyable time, but it was so nice to be back home again!                                                 girl, 12

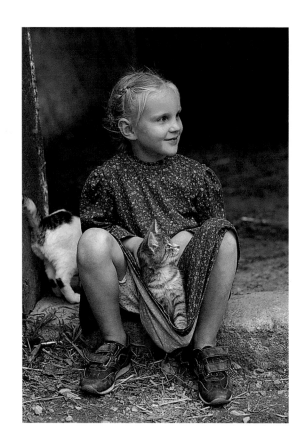

## THERE IS WORK TO BE DONE

On a summer's day I really like to go swimming, but first there is work to be done. I have to help with the dishes and make beds and tidy my room. And sometimes I have to help my dad in the barn. I like to go swimming because it is fun with my friends.

When I grow up I will be a homemaker. I will have a husband and some kids. My husband will have a shop, but not as big as a barn.

We Mennonites are different because we have buggies and others have cars. For threshing, we have threshing machines and you often don't even have farms. You have radios and TV's. We are not the kind of people that have things like that. We don't have so much decorations and photos.

*girl, 11*

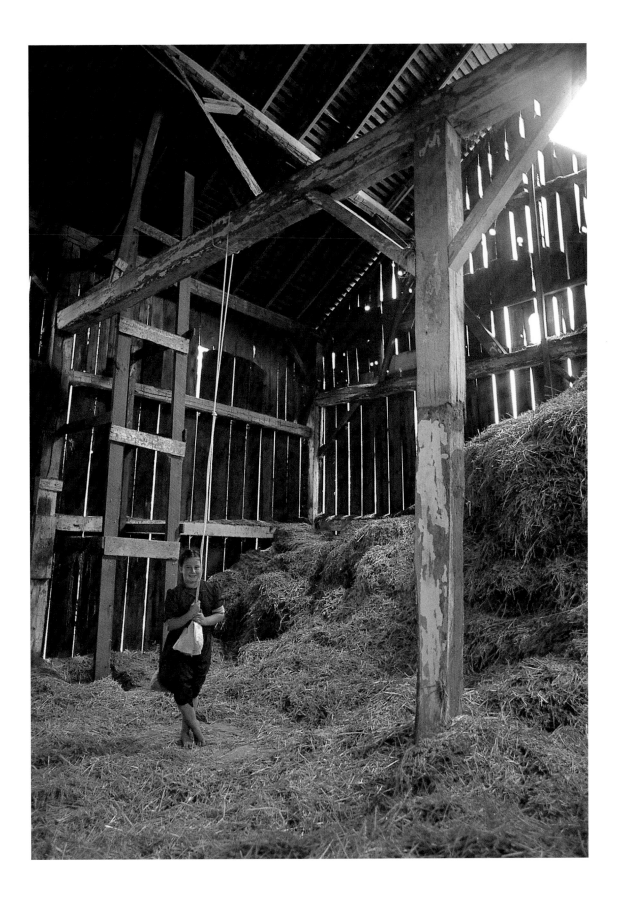

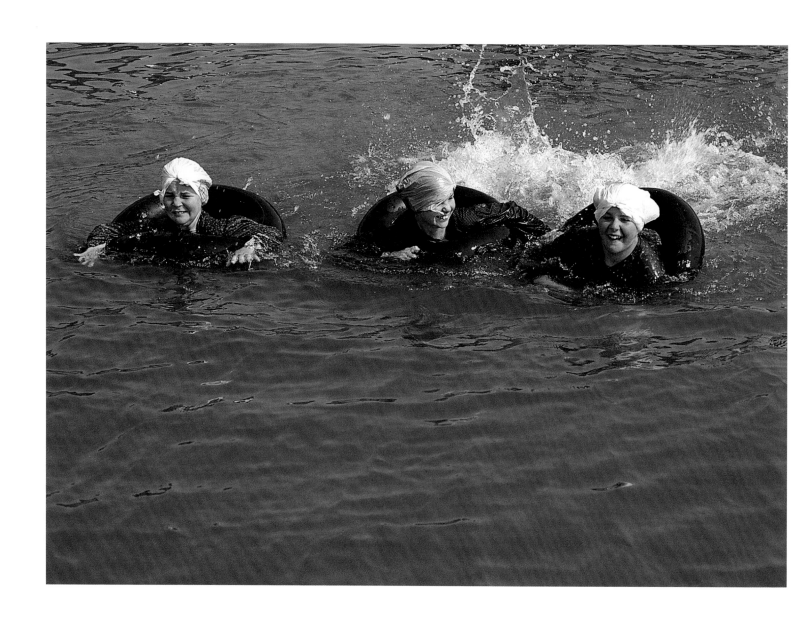

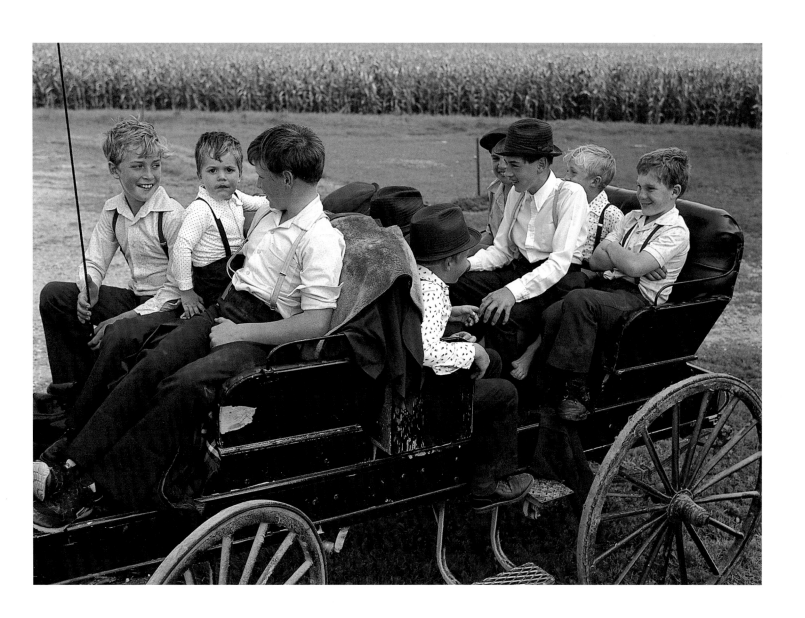

## PLAYING CARL HIEBERT

It was late afternoon when I pulled into the driveway of a farm I had not visited before. At least not on the ground. Earlier that summer I had swooped over the pine trees with my ultralight and sent handfuls of candy tumbling into their yard.

Two sisters and a neighbor girl were playing *dach waglie* (covered buggy) when I arrived. With a blanket stretched between packing boxes, their make-shift carriage — even without a horse — had taken them miles through imagined country roads. I joined their fun and about an hour later, Elizabeth suddenly turned to me and said, "Well, just before you came today we were playing 'Carl Hiebert.'"

"I've never played that before," I told her. "How do you do it?"

She picked up a handful of stones from the driveway and then skipped off behind the house. Seconds later she returned, arms outstretched, mimicking an engine noise, running full-speed toward us. As she flashed by, she threw down the stones and laughed as her two playmates dove to the ground and pretended to frantically search for another gift of candy that had fallen from the skies. (author)

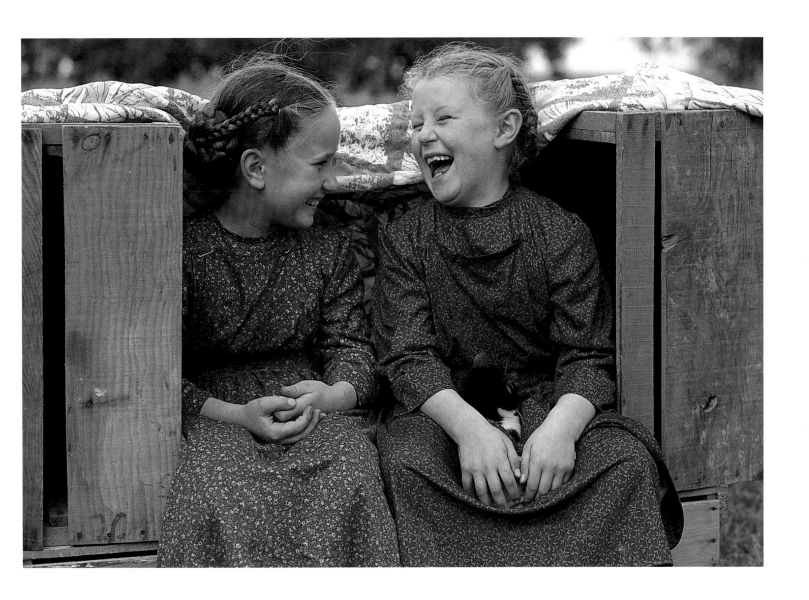

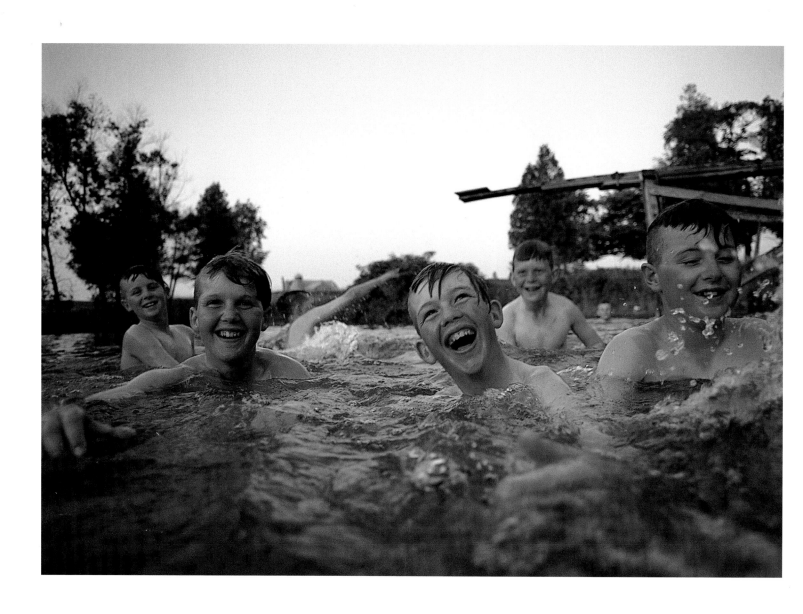

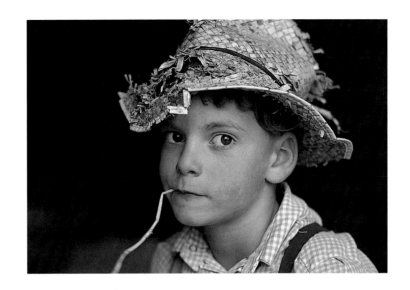

## A THREE-STORY BARN

In the summertime, as soon as I get up I go downstairs and pull on my boots and go out to feed the pigs and manure out a few pens. Then it's time for breakfast. After, we sit at the table and talk. Then we go and finish the chores. Then it should be about ten o'clock. We fool around till lunch, and after lunch comes play. In the evening I go for a swim with my friends.

When I grow up I want to be on a farm with a little shop. I want to have 150 acres. I want to have a separate pig barn and a barn that is three stories high. The top story will be for the straw and hay, the middle story will be for the little piglets, and on the other side will be a feed mill and a threshing machine.

boy, 11

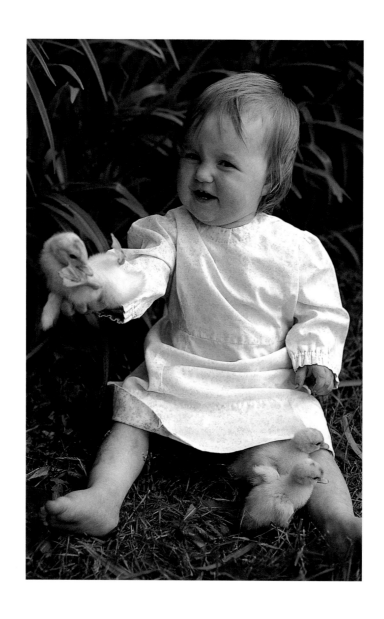

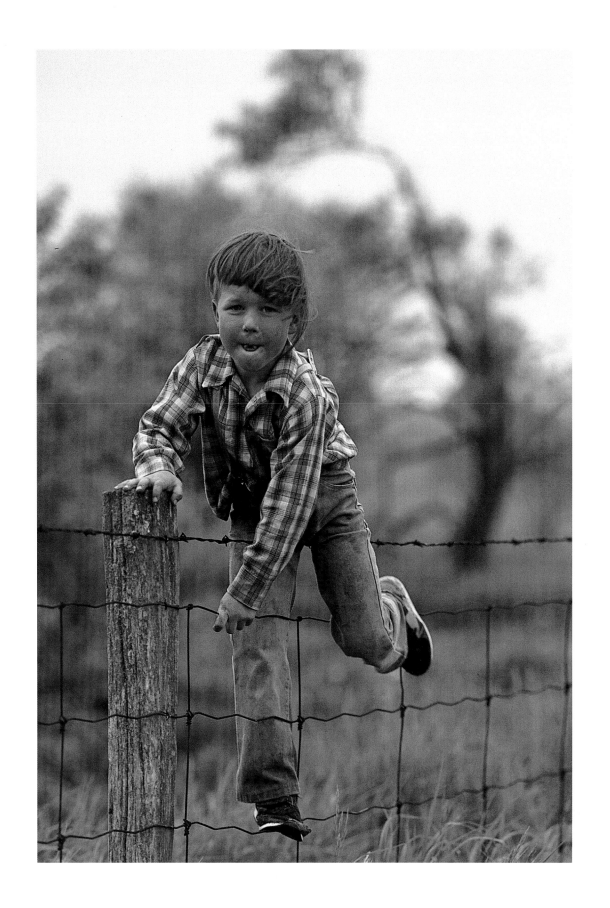

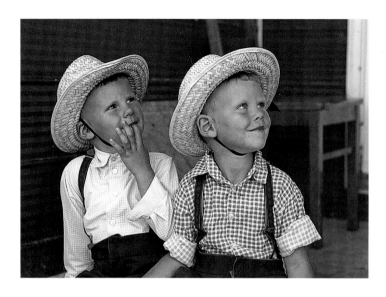

MY AUTOBIOGRAPHY

This is a story of my life, the years from 1980 to 1994, and interesting things that happened. A few of the years I can't remember anything.

| YEAR | EVENT |
|------|-------|
| 1980 | I was born, May 30. |
| 1981 | On a nice Sunday afternoon in the summer, my brothers (twins) and I were playing on an elevator by the shop. Dad and Mom were on the porch reading when someone screamed because I had fallen off the end of the elevator, about ten feet up. |
| 1982 | My sister Esther was born, January 10. |
| 1983 | My brother Oscar was born, August 23. |
| 1985 | My sister Annie was born, September 29. |
| 1986 | We built an addition to the house. |
| 1987 | My brother Paul was born. |
| 1989 | My Dad got hurt when the horses tried running away. The reins got caught in the wheel and pulled him off. |
| 1990 | Klearview church was built. My sister Mary was born, May 26 |
| 1991 | My dad became a caretaker at the church. The Deacon ordination was held. |
| 1992 | We went on a school trip to the *Kitchener-Waterloo Record* and Home Hardware. My grandmother died October 15 from a heart attack. |
| 1993 | My sister Sarah was born, February 29. |
| 1994 | On June 7 we went on a school trip to Doon Pioneer Village. |

This is the story of my life.

*girl, 14*

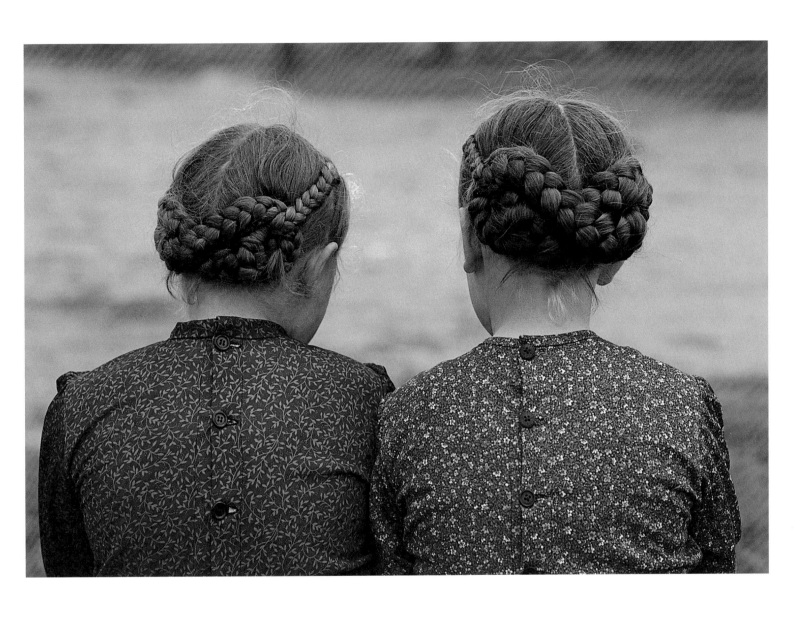

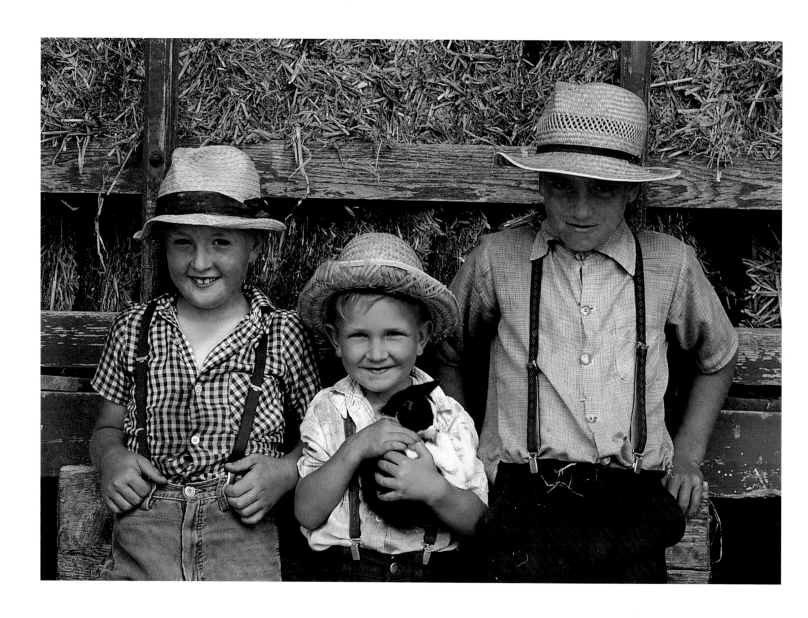

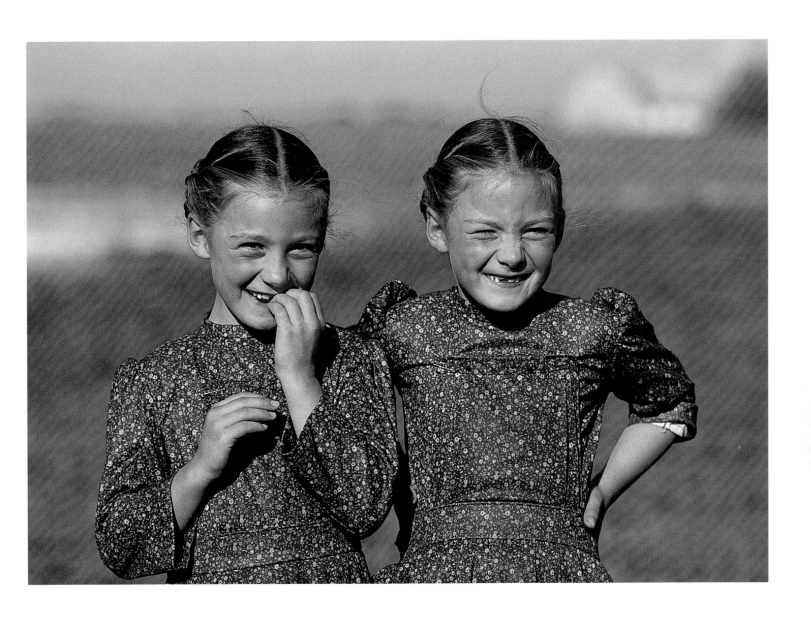

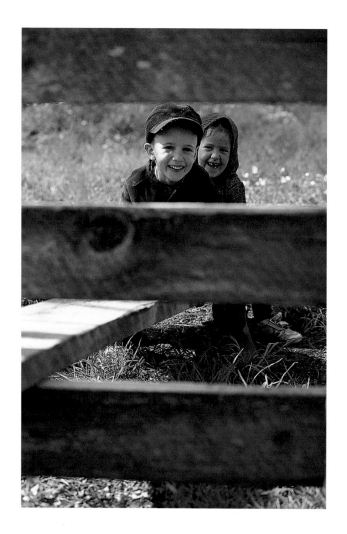

## THE BROKEN MOON

Two-year-old Lester had been out in the barn with his parents, who were doing chores. It was dark by the time his mother led him back to the house. In the clear winter sky, he was suddenly struck by the apparent brokenness of the new sickle-shaped moon. "Da moon is vabrocha," he explained. "Da Dad mus fixa." His father was a carpenter and could fix anything.

A few nights later, when Lester glanced through the kitchen window, he noticed the moon again, this time full and heavy in the sky. "Guk!" he shouted happily. "Da Dad hat moon fixed. Er hats lange kene." (He has a long reach).

(author)

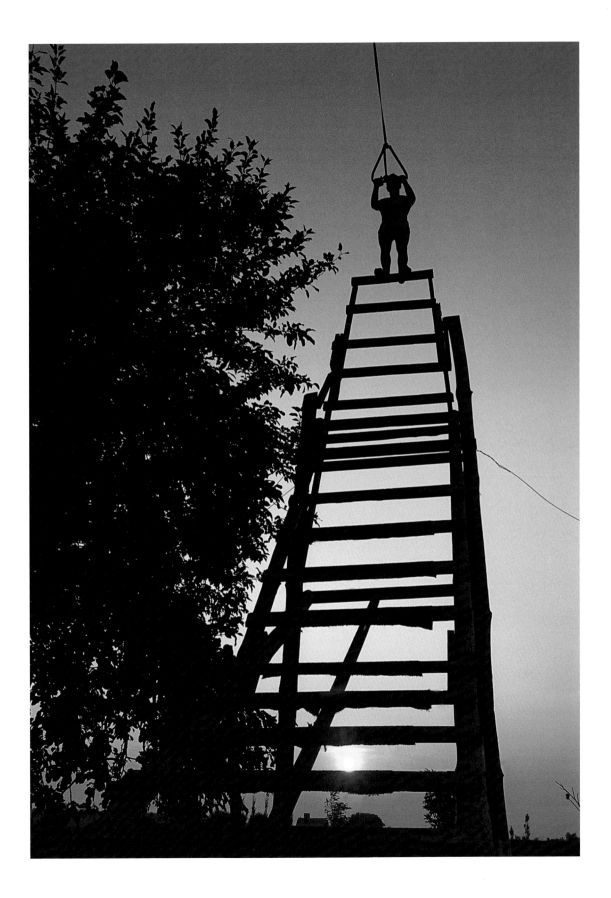

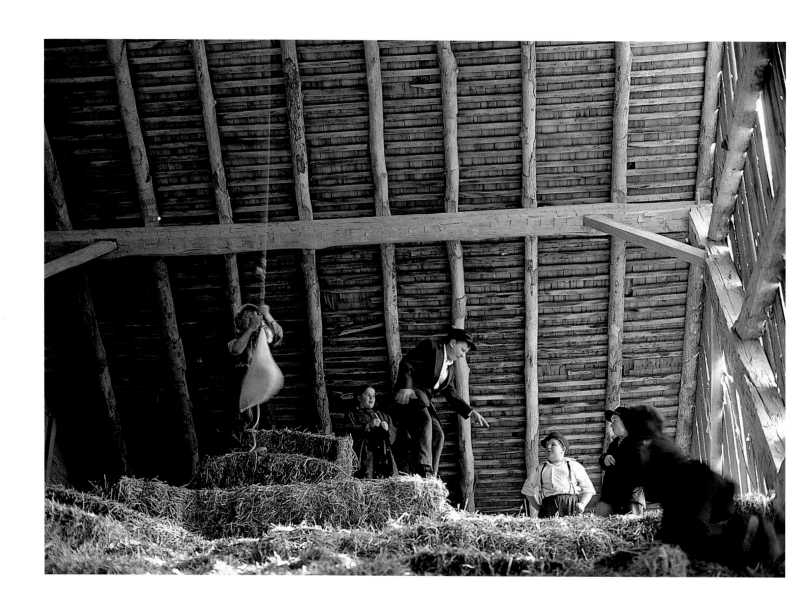

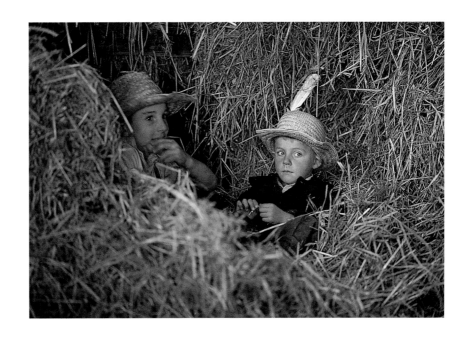

## THE BUSIEST TIME OF YEAR

Autumn is the busiest time of year. Carrots and potatoes need to be dug up and stored in the cellar.

Pumpkins, squash and zucchini need to be carried in. While a harvester howls in the distance, in another

field someone bounces on a tractor, plowing, with seagulls flying all around. Somewhere else, a farmer sows

winter wheat. Colored leaves blow in the brisk autumn breeze. A mother fits some winter clothes on her

child. Migrating birds fly overhead. These are the things one sees in the fall.

girl, 11

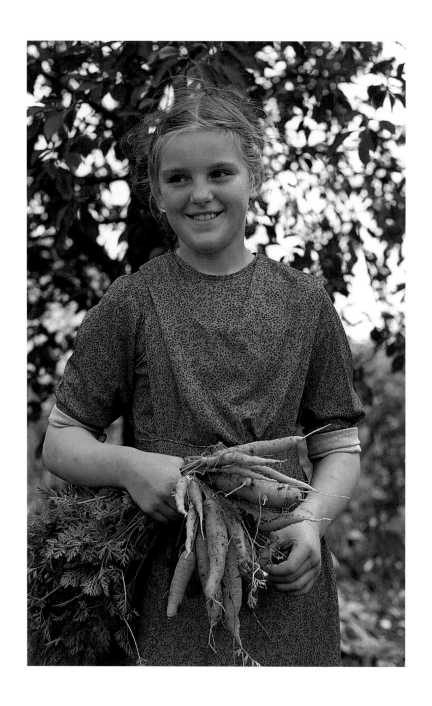

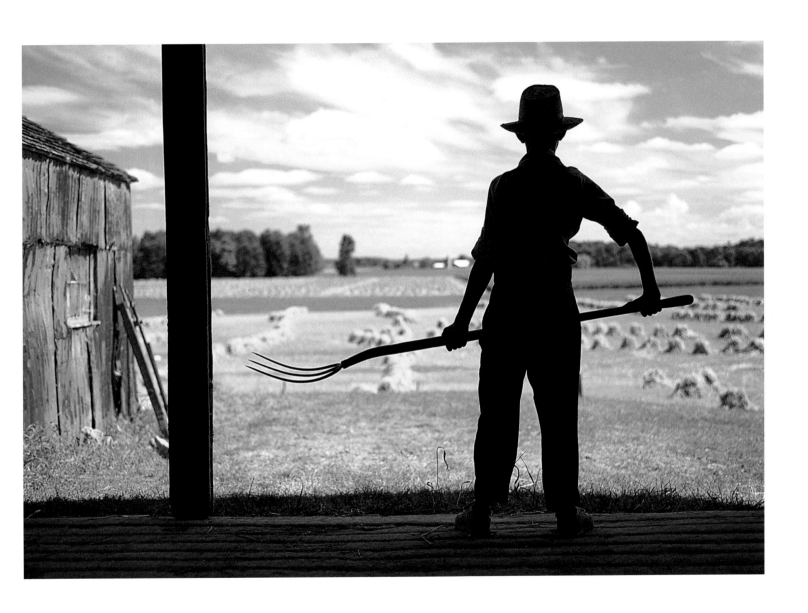

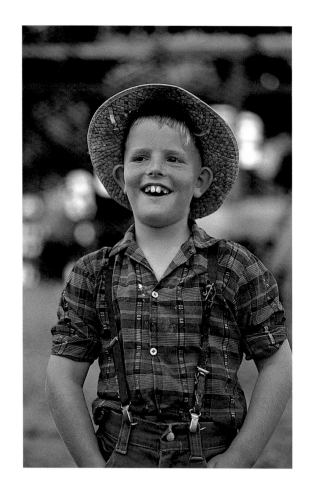

## THE HUNTER

My favorite game is hunting because it needs so many skills. I think I like it because my dad used to be a hunter. I love hunting with a bow-and-arrow or slingshot. I also like to play hide-and-seek. We play it at night, after dark, when we are done our chores. It sure is fun. I like to go for a walk in the bush with my parents if they have time. I also like to sing out of the *Philharmonia* with my parents. A *Philharmonia* is our community songbook that has English and German songs. I already know thirty songs.

When I grow up I want a farm with 300 acres. I also want to be a hunter and maybe have a fish pond and a swimming hole so I can make money.

Mennonites drive buggies and others don't. We don't have radios or TV, and we don't get house-builders to build our house.

On a summer's day I go down to the bush land with friends. We make long trails to Jesse's side of the bush. Or make a new house out of sticks. Or we play by the pond and collect fungus.

boy, 10

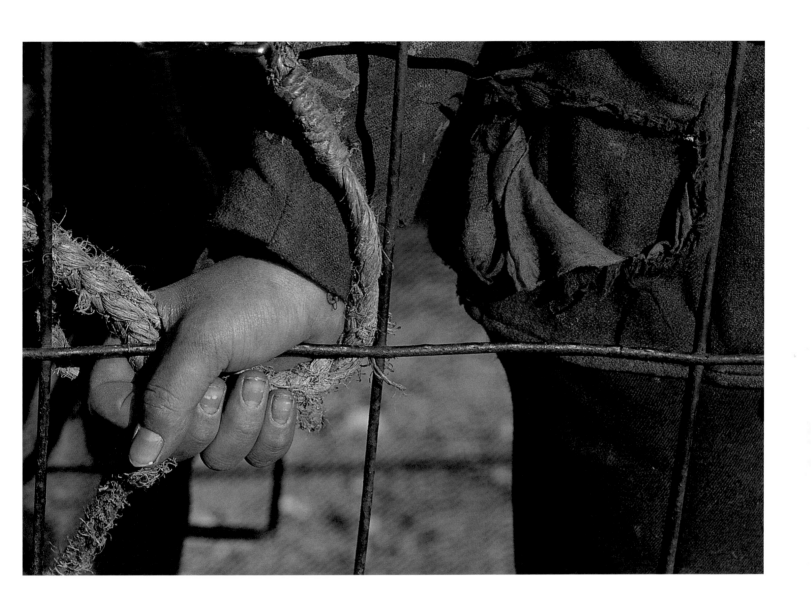

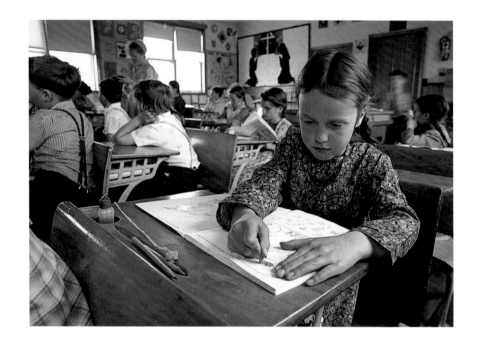

## NOON PRAYER

We thank you, Lord, for happy hearts,

For rain and sunny weather.

We thank you, Lord, for this our food,

And that we are together.

Be with us, Lord, both night and day,

And guide us in our work and play.

We say the noon prayer each day at school just before eating. The teacher says, "Class stand,"

and then we bow our heads, close our eyes and fold our hands. Our teacher always leads it,

then we join in. After, we are dismissed by rows. It is important for us Mennonites to pray

before eating, to thank God for all the food He gives us.

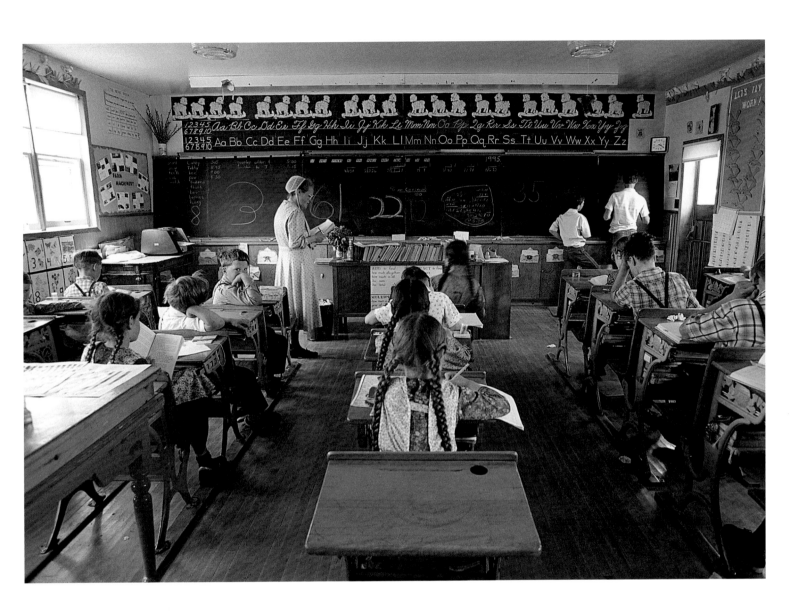

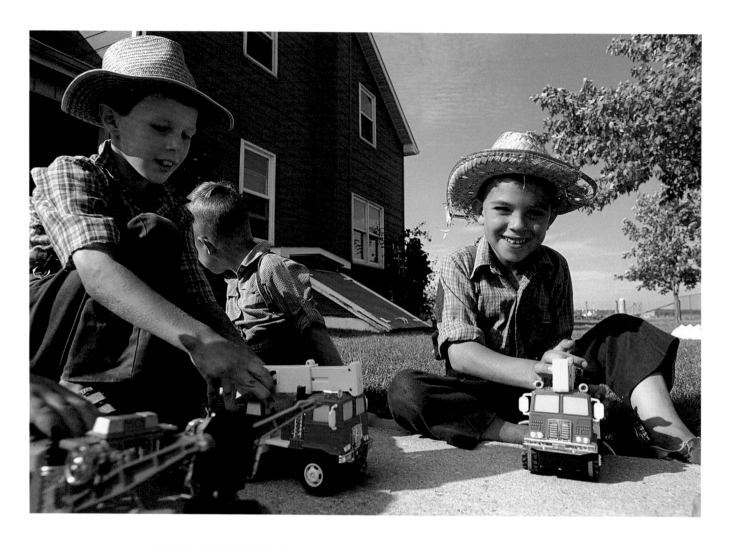

## MY LITTLE TREE

When I was five years old, I went to my grandmother's house because my mom had to help her with her garden. My grandmother was on crutches because she hurt her leg.

While I was pulling weeds in the garden, I found a little walnut tree, so I dug it out of the soil. I put the seedling and roots in a margarine container and added some soil and water.

When my father came to pick us up, I almost forgot my tree. My mom ran back and got it and set it beside me in the buggy. I picked it up and held it all the way home. I felt happy holding my grandmother's little tree.

After supper, I ran out to a little bush on the other side of the road. There I dug a small hole and my mom put topsoil in the bottom. Then I put the tree in, along with some cut-up fish around the roots. Then I added water and put grass over to cover the hole. Then I watched and watched to see if it would grow. But no, it wouldn't grow. The next morning I watered it again, and at lunch I watered it again.

One year passed, and then the little sapling was half as tall as me. I still watered it often. Another year passed, and now it is even taller than me. Soon I hope to pick the walnuts. That is going to be a treat for me. My tree has a short stem at the bottom with tiny leaves and a sharp point at the top, which is bent a bit. Some day soon I'm going to take Grandmother in her wheelchair to see our special tree. I hope she enjoys it as much as I do.

boy, 10

## PLAYING CHURCH

A child's choice of games often reflects that which is familiar in their lives. Enter a Mennonite kitchen on a mid-winter afternoon when cousins are visiting, and you might step into the middle of a children's church service.

It begins with a pretend ride to church, several miles away. Two sets of chairs, arranged neatly behind each other, make do for the required buggy seats. If there's a boy in the group, he's probably the horse-power — set for travel on his hands and knees, a skipping rope for his reins. And if the horse is particularly anxious, as commonly happens, he might just rear up on his hind legs.

Seconds later, the family arrives at church. The two bottom steps on the staircase become pews, and the service begins. Although there might be prayers, with children on their knees and facing backward, a sermon would be highly unlikely, for that would border on sacrilege. And no preaching also allows a two-hour service to be reduced to fifteen minutes. But there will be singing, unabashed, for singing is a fundamental expression of worship and joy in this community.

Where the details are not compromised is in the care of babies. The children become almost perfect mimics of their mothers. Babies begin to cry and attentive mothers immediately leave for the cloakroom to still the tears or change diapers. Good fortune would be to have a toddler in the crowd who might just enter into the spirit of the play and cry on demand.

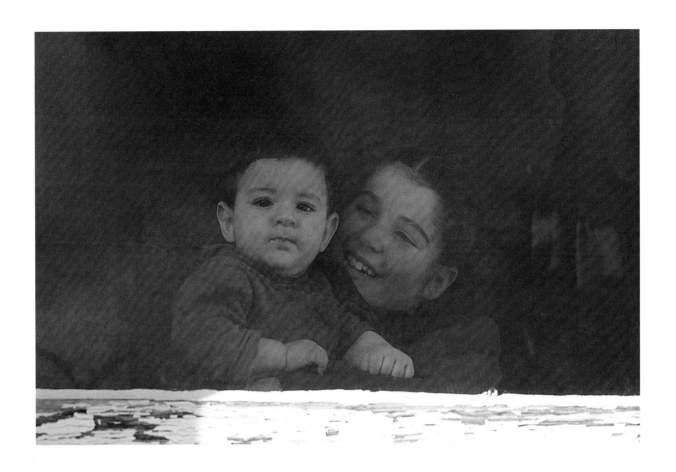

When enough babies have been lulled to sleep, the service ends. Now the women must wait for their husbands to come by with their buggies for the ride home. Adult-like conversations continue. "Have you canned your peaches yet? Did you know Mrs. Martin is down with the flu? Did you know about the Hochzeita [wedding couple]?"

Suddenly, the children are tired and respond to a more immediate reality: "Mam, ich bin hungerich!" And a plate full of homemade chocolate-chip cookies quietly ends a well-imagined Sunday morning.

(author)

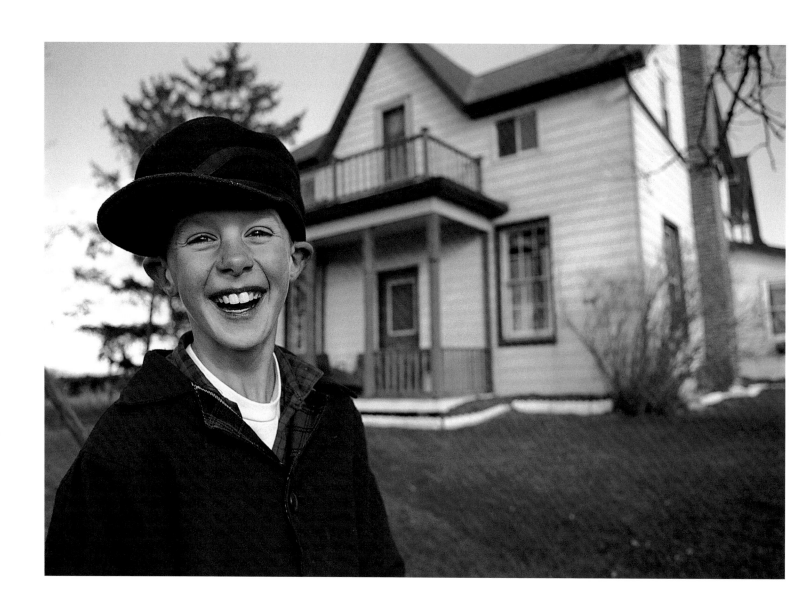

## NO SUNDAY SALE

Henry was only five years old but had already established himself as a successful vendor.

His little express wagon was loaded with goods. Wooden blocks wrapped in discarded

newspaper were the choicest of apples or tomatoes. The other end was piled with short

boards — fish, a choice of perch or whitefish. Stretch your mind far enough, and you could pretty much get anything you wanted. Older sisters had made labels to identify his products, and by time Henry had finished making the rounds to his mother, aunt, the hired girl, and grandfather, he had his price list memorized. All sales required a necessary transaction of pretend paper money. As he finished his last sale and turned back toward the house, you could see the tell-tale badge of a true Mennonite merchant. Part of a broom handle was wedged into the back of the wagon, and taped at the end was a cardboard sign that read, "No Sunday Sale."

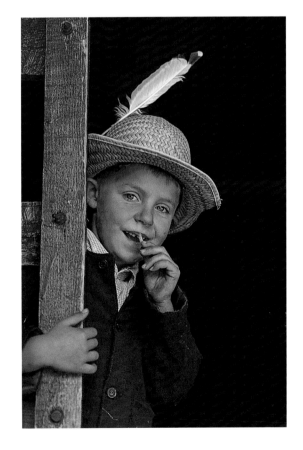

(author)

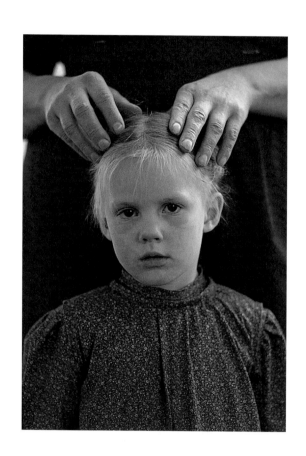

## A MATH WORKSHEET

This school year is like a mathsheet

The Master has handed to you

The four basic functions are needed

In the work you are given to do.

Some problems require addition

Of diligence, virtue and faith

And some of them call for subtraction

Of laziness, carelessness, hate.

For choosing the right in decisions,

Division you'll need to employ.

Make good use of multiplication,

With cheerfulness, kindness and joy.

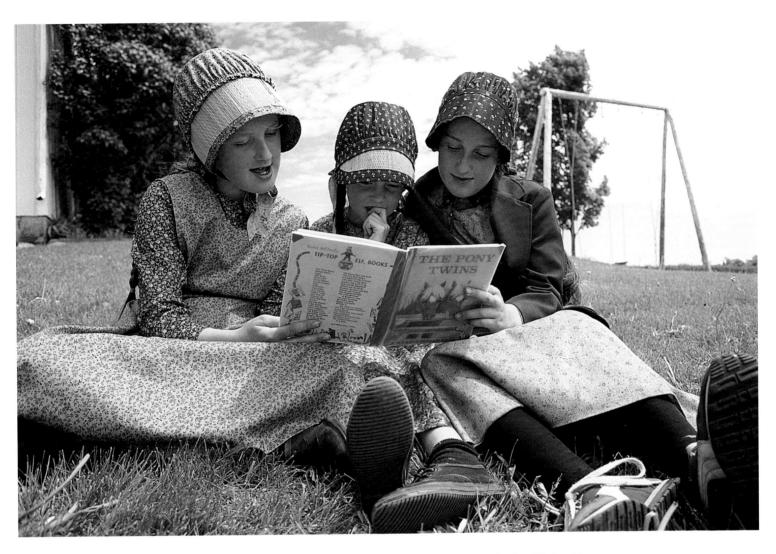

Check over your work and be accurate:

Small errors affect the whole sheet.

And guard against streaks of indifference

Or blotches of ugly conceit.

What note do think will the Master

Inscribe when the school year is gone?

On your sheet, "Unsatisfactory"

Or will He write, "Very well done?"

(First page of a student's notebook)

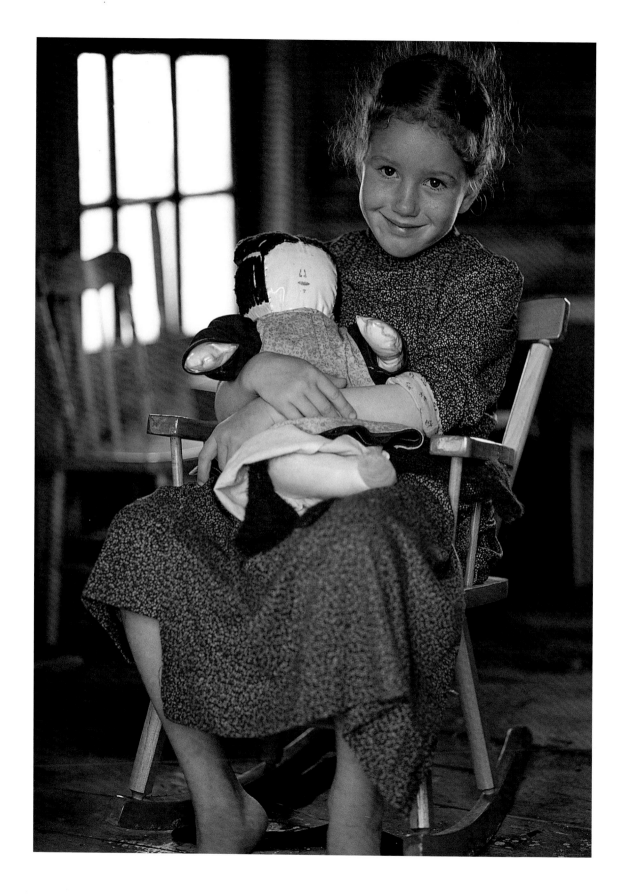

## LIFE ON THE FARM

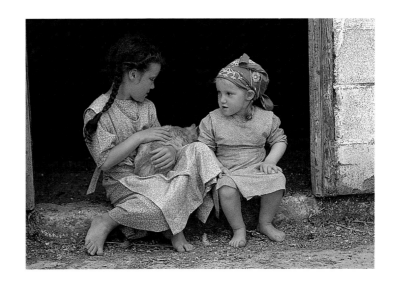

I like to live on the farm because it is fun.
On our farm we have big turkeys, horses, pigs,
hens, cows and calves. We have to feed the
animals on the farm. We feed the beef-cows
turnips. When our turkeys get upset, their heads get blue. It looks very funny.

We have ten cows to milk and we use milk machines to milk them. My mom
makes cheese with the milk and it is good. We sell the cheese and eggs at our farm.
When the hens don't lay eggs anymore, we give them away.

My favorite animals are dogs, horses and ponies. My mom's favorite animal is a
horse and my brother's is a bunny.

On our farm we can skate. We don't have to make a rink or flood the ice, because
we can skate on our laneway just outside our door when it gets icy. In the winter we can
build tunnels in the snow. Life on the farm is busy and fun.                    girl, 9

*(Comments by her mother, written in the back cover of her notebook: "Yes, life on the farm is satisfying. This story explains it all!")*

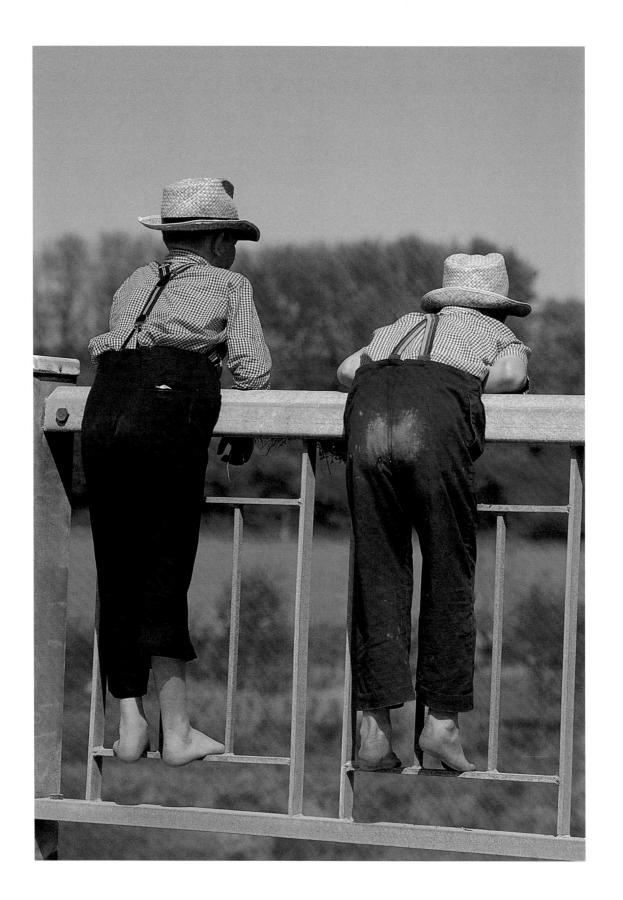

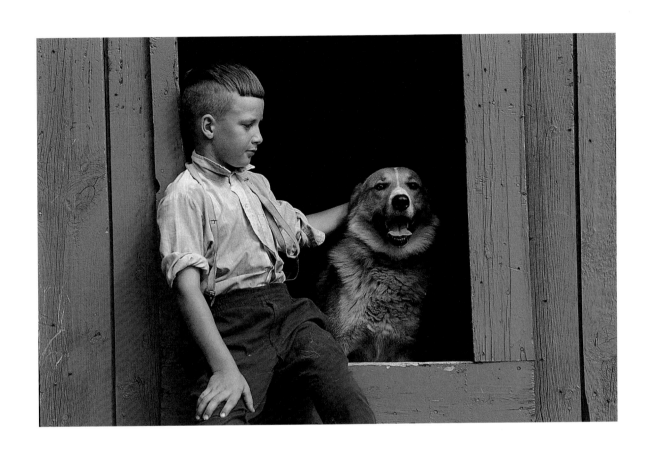

## MY FAVORITE RIDE

One bright, cold Sunday afternoon, while driving the back country, I saw a crowd of my young friends enjoying their favorite winter pastime, tobogganing. They recognized my car and crossed the field to visit. I rolled my window down and said I'd like to join them but couldn't because of the wheelchair. No problem for these energetic souls. They soon had me lying flat on a toboggan, sliding under the fences back to their hill. I realized quickly enough that the most exciting photo opportunities were to be had from the bottom. Three rolls of film and an hour

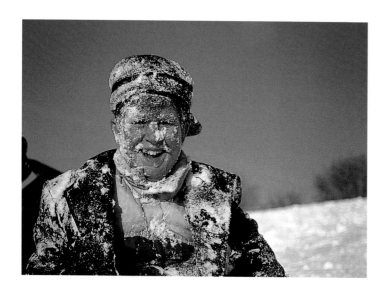

later, I was shivering. I wish someone could have photographed my ride back to the top. The children tied extra rope to my sled and, as a team of a dozen black-clothed "horses," they dragged their payload step by sliding step up that long hill. I laid on my back, bathed by a dazzling winter sun and by the warmth of their laughter and acceptance. (author)

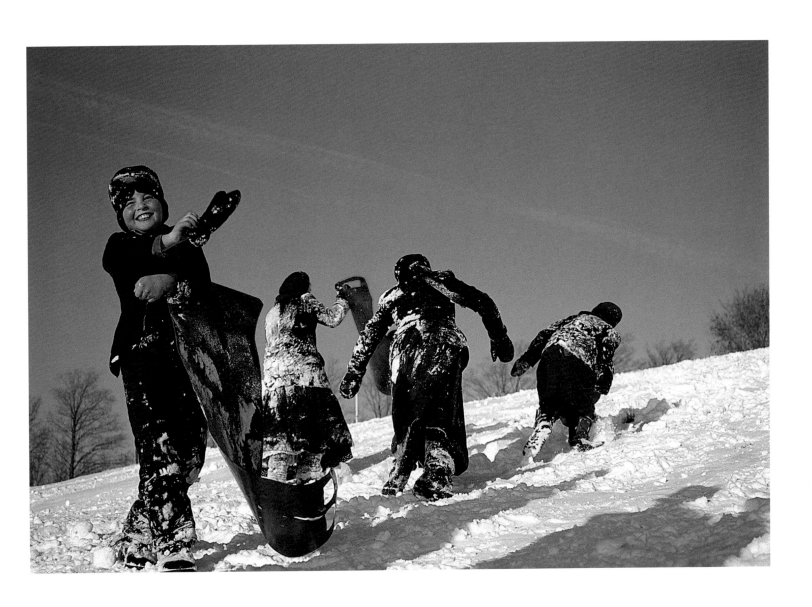

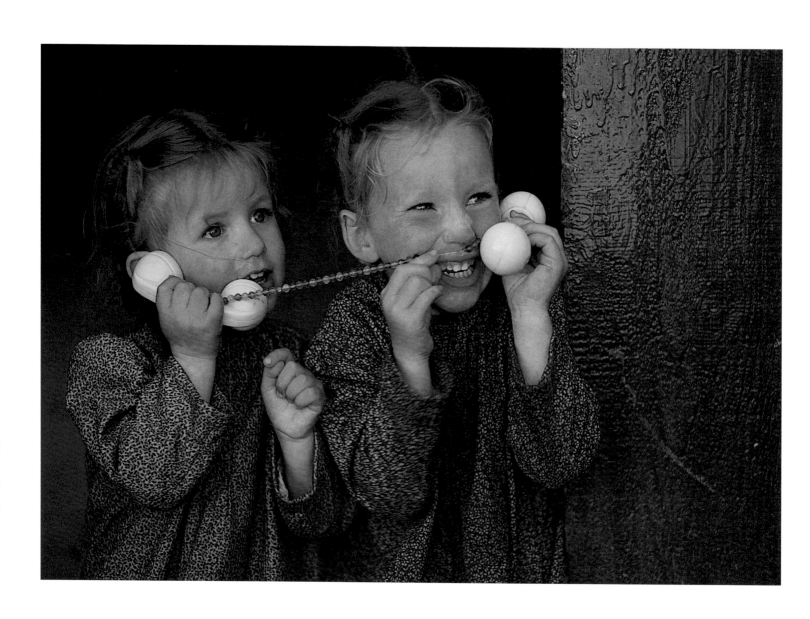

## SINGING

One Sunday morning I asked my mom if we were having a singing. She said, "Yes, we are." When we came home from church, I asked my mother if we were getting visitors. We had two tables full of boys and girls! At last, the supper dishes were washed and the other girls and boys began coming.

"You might as well go upstairs right away. You may go in the boys' room and listen," Dad told us.

We went upstairs and Mom closed the door. We all sat around the register so we could hear better.

"Move over, please. I want to hear, too," Laurence told me. I moved over.

"Move over," Maynard told my sister Arlene. So she moved over nicely and everything was quiet for a short time.

"I want to be under the bed," James said. Soon he was under the bed and sound asleep.

Everything was quiet, and the singing was over all too soon.

girl, 10

(Author's note: I have been privileged to attend several Mennonite "singings." Many Sunday evenings, young people from age fifteen to late twenties gather in someone's kitchen for hymn-singing and games. On one occasion, 110 voices filled a kitchen, in four-part harmony, for over two hours. Singing is high on the list of recreational activities for most Mennonites.)

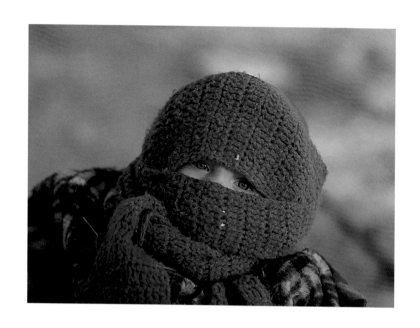

## MY FAVORITE HOLIDAY

I think Christmas is the best time of year. This is when we remember and celebrate Jesus' birthday. We also have many family birthdays in that month. My sister's birthday is just before Christmas, and my dad's and mine are only a few days after. Another reason why I like Christmas is that by then we will be skating — or soon after. What fun it is to glide over a smoothly frozen pond, with clean white snow on the edges. Another thing I look forward to is the gatherings. Once a year, we have a Christmas gathering where all the relatives on my mother's side of the family get together. My grandfather's first wife died, and he remarried. Now there are about a hundred cousins all together. Grandfather is seventy-eight and is the oldest person there. My grandparents give every child a gift, so we usually have lots of fun. We also have our own private Christmas dinner at home. My brother, five sisters, three brothers-in-law, two nephews, Mom and Dad, and myself all crowd around our table. After dinner, Dad reads the "Christmas Story." Then we exchange gifts. Yes, Christmas is a good time of year because it makes me feel excited and joyful. girl, 11

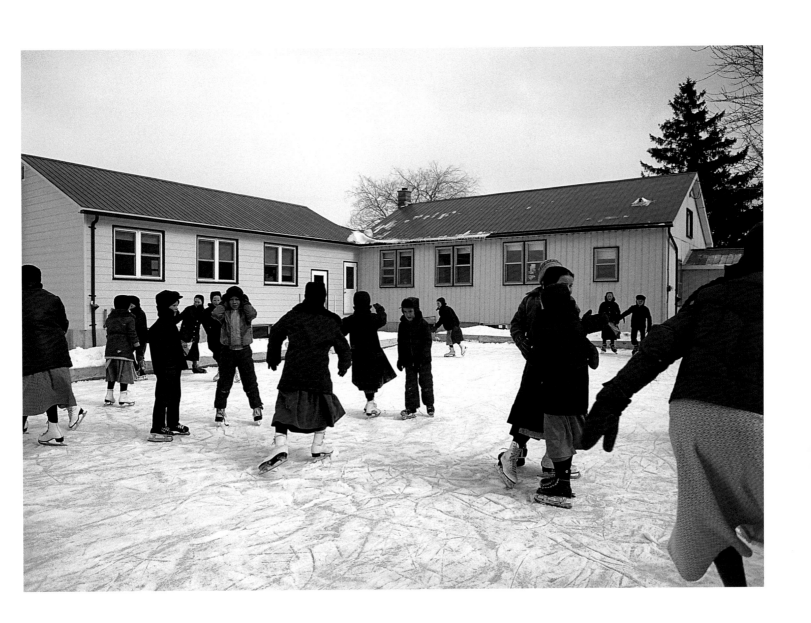

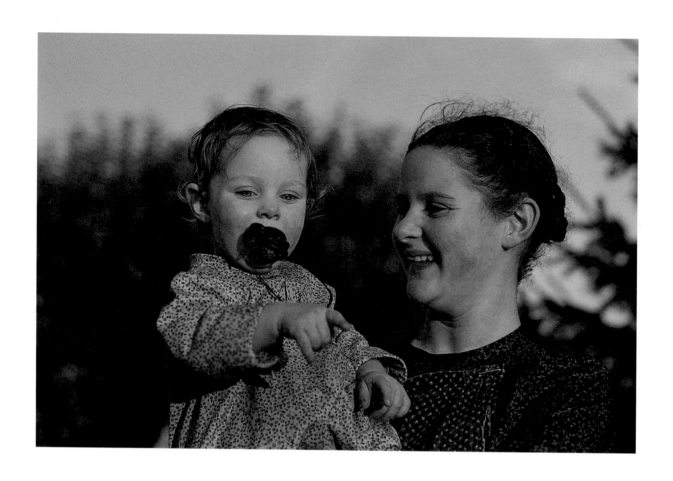

## NOW WE CAN BE THANKFUL

Out in the field the harvester is going. Back and forth the wagons go. All day the harvester

goes. I can see the green corn go into the back of the wagon. I can see it unloading. Puff, puff,

out the back it comes. At last the job is finished. Now we can be thankful for all we have done.

boy, 9

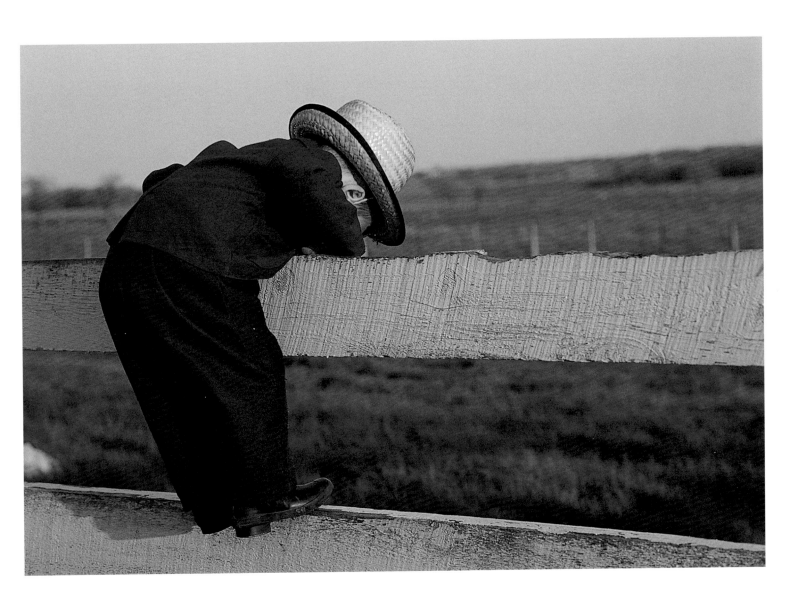

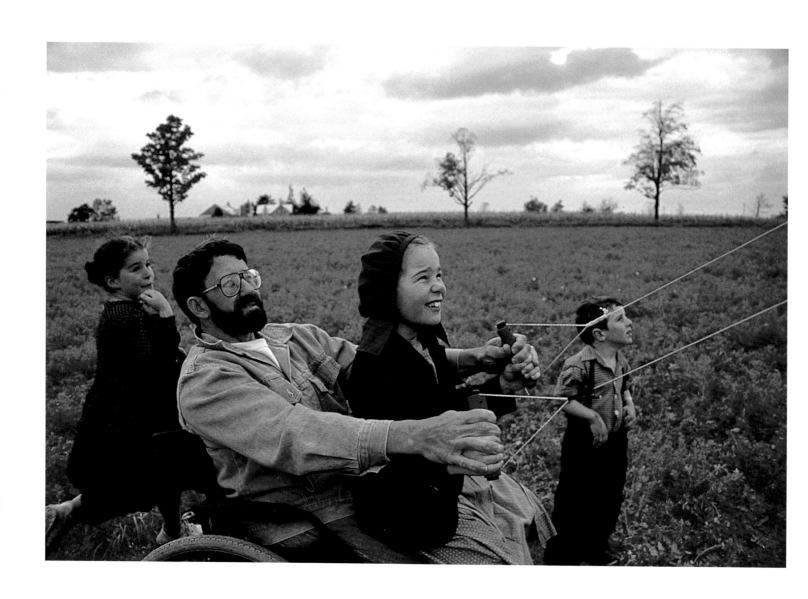

## AFTERWORD

As I had hoped, they are already here. I pull over to the side of the bridge and roll down the car window. "Hi, guys," I shout, momentarily interrupting about twenty Mennonite boys involved in a Sunday-afternoon hockey game. Sticks wave in the air and several players yell back their greetings. Arenas don't get any better than this — a frozen bend in the river and open blue sky above.

I watch from my distant bleacher, the sun hard on my face. For several minutes I am caught up in the play-by-play action, but the swirling figures begin to blur in the sunlight and memory pulls me back to my own childhood, to another hockey game, this one down at the marsh.

Two pairs of rubber boots sit on the ice as makeshift goalposts. Our shin-guards are newspapers held up by rubber jar rings. We play hard for the entire afternoon and then walk the two miles home, with chores to do when we arrive. We are exhausted. There are no playoffs and no one takes home a trophy. But the memories are sweet.

In a way, I have come full circle, from childhood to adulthood, and through my time with these Mennonite children, back to my own childhood again — a rediscovery of simplicity and joy.

I think of the pace of our lives today, and I wonder...

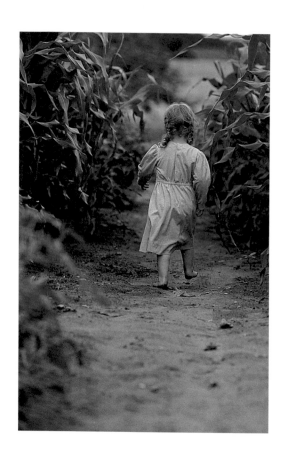